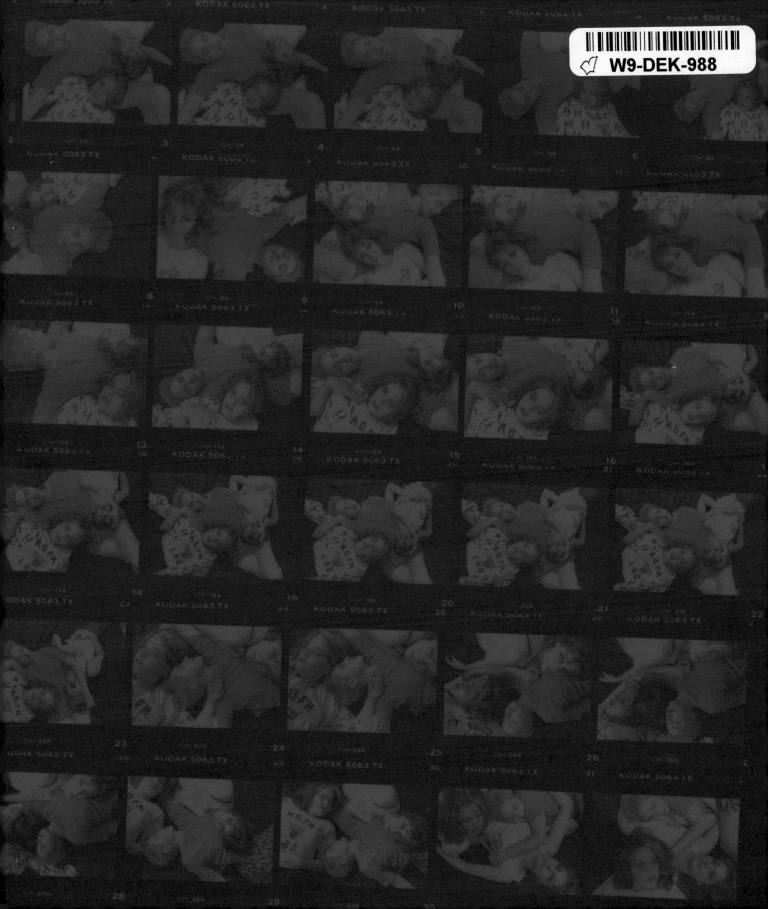

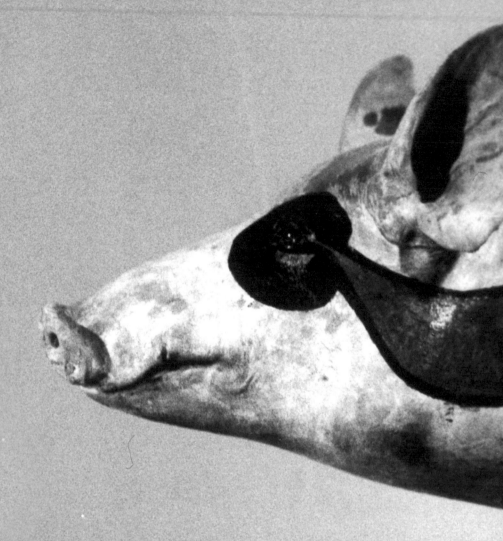

Mastering

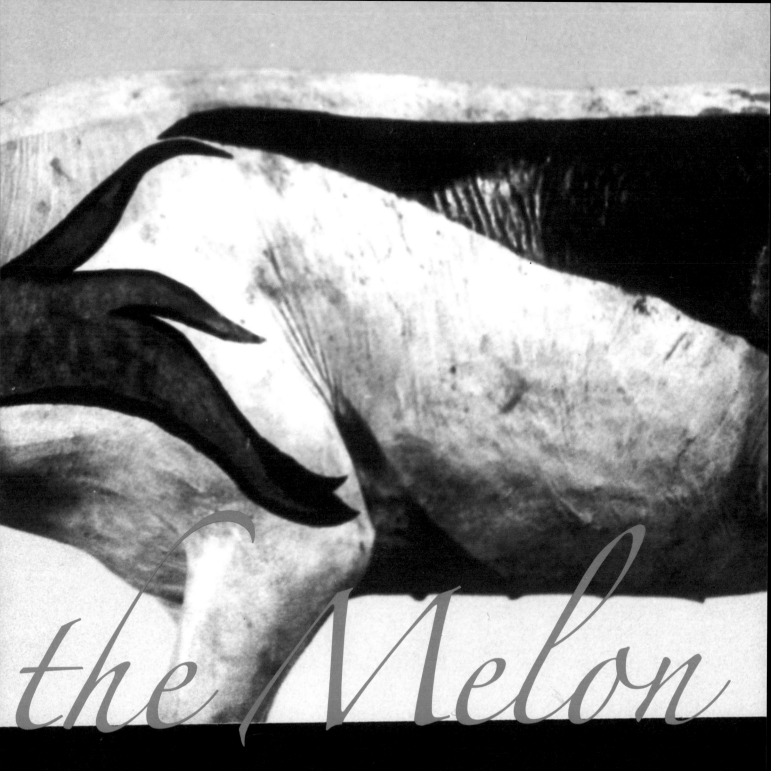

the Melon

PROJECTS BY ALIX LAMBERT

MASTERING THE MELON
PROJECTS BY ALIX LAMBERT

Edited by Ariana Speyer
Design by Stacy Erin Forte at Evil Twin Publications

Published by: Galería Javier López, José Marañón, 4 E-28010 Madrid, Spain
www.galeriajavierlopez.com

"Artist as Thief-in-the-Law" © 2006 by Tim Griffin.
"The True Story of a Fake Band" © 2006 by Amy Kellner.

Front endpapers, photos: Carl Saytor, Janine Gordon.
Back endpapers, photos: Phoebe Sudrow, Daniel Pereira, Robert Melee.
Publisher page, photo: Peter Strietmann.
Page 124, photo: Lalou Dammond.

ISBN 1-933045-40-X / 978-1-933045-40-5

First edition printed April 2006.

Library of Congress Cataloging-in-Publication Data

Lambert, Alix.
 Mastering the melon: projects by Alix Lambert.
 p. cm.
 Includes index.
 ISBN 1-933045-40-X
 1. Lambert, Alix — Catalogs.
 NX512.Z9L362 2006
 709.2—dc22
 2006010079

It would be impossible to overemphasize the patience, talent, and support of the following people in creating this book: Christina Cho, everyone at D.A.P., Stacy Erin Forte, Tim Griffin, Amy Kellner, Javier López, Tim Nye, Ylva Rouse and Ariana Speyer.

I would also like to thank all of the friends, family, spouses and collaborators who helped to bring each individual project to life.

Artist as Thief-in-the-Law

TIM GRIFFIN

Concerning this a man once said: Why such reluctance? If you only followed the
parables you yourselves would become parables and with that rid of all your daily cares.
Another said: I bet that is also a parable.
The first said: You have won.
The second said: But unfortunately only in parable.
The first said: No, in reality; in parable you have lost.

—Franz Kafka, "On Parables"

1. If a single epiphany in Alix Lambert's work may be said to speak to the
whole of her practice, it is likely found in *The Mark of Cain*, the artist's remarkable portrait of the
Russian penitentiary system as seen through the prism of its convicts' tattoos. In this documentary
film, prisoner after prisoner appears before the camera to explain the elementary significance of
the imagery woven into his skin, a whole lexicon seeming to come into focus with each new
testimony. Every cupola in a cathedral represents a conviction; a sailing vessel signals a life of
wandering; a heart skewered by a dagger identifies a killer for hire; and, most importantly, the
image of Christ on the cross tattooed on one's back means that one is a "thief-in-the-law."

It is the thieves-in-the-law who provide Lambert with her story and, by the work's conclusion,
with her critical insight. Belonging to a recognized (and self-aware) culture within the prison, they
first detail for the artist a language that corresponds to their tattoos without ambiguity. Indeed, the
dramatic images they present—magisterial battle scenes, citadels, or spiders; cherubs or the
Virgin Mary—nearly obtain in their description the absolutism of medieval iconography. Of
course, in light of such a one-to-one equivalence, this illicit community's chosen nomenclature
would seem utterly paradoxical: for a thief is usually understood to be someone who trespasses the
law, whereas the term "thief-in-the-law" suggests a more complex criminality, at once subverting
and upholding authority and systemic code—violating the legislation of a given country, yet

2

acknowledging and acting according to the idea of a universal order. The figuring of this apparent paradox is only starker as Lambert's film continues, since over the course of the interviews it becomes increasingly clear that different systemic registers exist simultaneously for this kind of thief. As one prisoner says, offering in his explication of one tattoo the clearest articulation of the contradictions in play: "I am a slave to fate, but I am no lackey to the law." In other words, a nation may legislate—and may even claim certain truths to be self-evident as a basis for the organization of society and its subjects—but a thief-in-the-law is one for whom a sense of order and, subsequently, of identity is never steeped in such idealistic (to say nothing of Enlightenment-age) abstractions but, rather, only in physical reality and the inscrutable twists and turns of lived experience.

And herein rest the conditions for Lambert's epiphany: the prisoners are eventually forced to address not meaning in their tattoos, but rather meaning's loss—and they are made in turn to confront their own, more abstract inscription by institutional, cultural, and economic forces. Lambert's interviewees begin *Cain* by observing that tattoos, when they first appeared in prisons during the early twentieth century, provided a kind of open book on a prisoner's life, each image a scripture unto the fabric of his being. The visceral connection between identity and body was underlined by the hard fact that the pictures were typically made using a prisoner's own urine mixed with a fine black dust made from burning the sole of a boot. (This formula is, in fact, still used today.) These images, observes one prison authority, thus allowed society to "tell [a prisoner's] tastes and interests, crimes, his place in the world."

But in recent years a new generation of prisoners has introduced an irreducible gap between appearance and reality, throwing the culture of the prison into disarray: "It is," as one prisoner says toward the conclusion of Lambert's film, "impossible to tell who is who." And this new gap, the prisoners realize, runs from everyday social interaction all the way to ideology: the loss of the tattoos' fundamental indexicality is, after all, a direct consequence of the collapse of the Soviet Union. "Everything is done through money; something can be bought by an eighteen-year-old now," complains one convict, describing how oligarchic Russia has created a new generation of criminals who adorn themselves in symbols having nothing to do with their actual experience. Even punishment would seem to have lost its logic, says another, telling the story of one criminal who received a five-year sentence for breaking a window while another received three years for murder. Such enigmatic justice makes Deleuze and Guattari's reading of Kafka's "In the Penal Colony" seem like mere journalism: "The law can be experienced only through a sentence, and the sentence can be learned only through punishment. No one knows the law's interior."

Order of every category, it seems by the end of *The Mark of Cain*, has disintegrated, since appearance and reality are irrevocably separated—such that reality has, in a sense, merely given way to appearances. And fittingly, Lambert's film, which began with a historical account of prisoners obtaining tattoos of Lenin, Marx, and Engels (however cynically, since convicts knew that guards would refuse to riddle those ideological visages with bullets), ends with a discussion of mere fashion. Losing their original physical and ideological bond to life, the tattoos, once the figurative cipher linking public and private experience and identity, may in fact disappear with the last convicts wearing them today—having become merely a matter of style, and hence susceptible to style's cycles.

2. To approach Lambert's work is first to consider a series of infiltrations. She repeatedly approaches and then incorporates herself into subcultural fields: the tattooing community, for example (Lambert's entry to the Russian prison system was, in fact, gained through

contacts she made while attending the first-ever tattoo convention in Moscow); or the group gathering around small-plane piloting (which eventually led to her time spent in the Top Gun society of the Blue Angels, a unit of flying aces from the United States Navy); as well as the boxing society in New York and surfing elite of southern California (as in her short video *Box of Birds*).

On the one hand, as Lambert moves through these different subcultural spheres—each group, it's important to note, revolving around a specific, consuming interest or activity—her project is revealed to be a deeply philosophical, relativist one. She adopts and then displays the internal codes of each subculture, such that her continuing practice reveals each behavioral code as merely one among so many others. "They're all conservative," she once observed to me of subcultures in this regard, "at the same time that nothing is normal." Each of these individual spheres features a highly regimented hierarchy of behavior, in other words, and yet seen together they merely give the impression of an anthropological continuum, with no single sphere seeming of base value. (Of course, it is the rituals of mass culture that are bound to be destabilized most by this scheme, since mainstream culture becomes a kind of subculture, as is especially clear in *The Marriage Project*, 1993, for which the artist became married and divorced four times—once with another woman—in six months.) On the other hand, Lambert's project is resoundingly aesthetic, a kind of living tribute to poet Frank O'Hara's dandied adage of joyous subversion to natural, static order, "Grace to be born and live variously as possible." In other words, if infiltration is a fundamental aspect of Lambert's work, then this infiltration is only mutual, since Lambert must "learn" (and she is therefore both physically and psychologically permeated by) the codes, skills, and enthusiasms of any subculture she enters, from tattooing to flying to boxing.

But with this seeming contradiction—in which both Lambert and the subculture she engages seem instrumental at once—one may understand the real terrain of the artist's practice. Whereas critic Hal Foster once described an '80s generation of (mostly female) artists who appropriated and manipulated media imagery to reveal its operations, such that the signs of media became "both target and weapon," Lambert transposes this model of critique into the three dimensions of living. The target and weapon, in other words, is the artist herself and her subjectivity, as she apparently not only adopts a subculture's outward signs but also internalizes its attitudes by "learning" skills and sociological codes. Yet her practice involves, in turn, a vertiginous malleability, a continuously shifting boundary of interior and exterior. In this regard, one must consider that Lambert's dimensional migration in terms of appropriation took place in the '90s, against the backdrop of a commercial sphere where subcultural signs were routinely being used to sell products—where signs were displaced, losing their roots in lived life, in effect set free from the flesh. It is, as the thief-in-the-law would say, impossible to tell who is who. (This dynamic was discussed widely even in mainstream publishing at the time; consider, for example, Thomas Frank's discussion of countercultural motifs used in advertising in *The Conquest of Cool*, 1997.) Even more significantly, Lambert's practice evolved at the same time as did the "experience economy," in which attention, emotion, *enthusiasm* were articulated by corporations to be the fundamental elements around which commerce should take place: identity itself, in other words, is the commodity both marketed and sought, something that may be continually molded and reoriented. ("The consumer is our final product," as one corporate analyst put it.)

It is, therefore, the dilemma of the thief-in-the-law that Lambert confronts throughout her work. She seeks out the predicament, such that her practice evolves from the thief-in-the-law's elemental problem, showing and enacting the native codes of different subcultures even while subverting them. In this regard, it seems appropriate that Lambert at the end of the '90s would turn to satire, learning how to play drums for a fictional all-girl band, shooting a faux promotional video, *Platipussy*, in which all the bad behavior of rock-and-roll rings hollow—or is, more accurately, staged. Once appearance and reality were ruptured by consumer society, and the subcultural "look" could be had by anyone, the only source of novelty was experience itself. The artist, in turn, must

4

display the gap between subject and sign where mass commerce seeks to render that gap invisible by closing it. Lambert "performs" a performance of subculture already cut away from its source, creating an awareness of identity when its properties are abstracted by the flows of commerce and media: she becomes a performance artist for the age of reality television.

3.

In Kafka's aphorism "On Parables," the novelist begins with an observation that "the words of the wise" may have no use in daily life. "When the sage says: 'Go over,'" Kafka argues rhetorically,

> . . . he does not mean that we should cross to some actual place, which we could do anyhow if the labor were worth it; he means some fabulous yonder, something unknown to us, something too that he cannot designate more precisely, and therefore cannot help us here in the very least. All these parables really set out to say merely that the incomprehensible is incomprehensible, and we know that already. But the cares we have to struggle with every day: that is a different matter.

One wonders whether we may think of Lambert's individual projects as parables. After all, they do operate as kinds of allegories, seeming the stuff of both lesson and legend. As striking as her incisive play with identity is, after all, the mere fact that she obtained access to such "unknown" spaces as the NASA space-shuttle simulator, the Goodyear blimp, and the Russian prison system's crown jewel of cruelty, the White Swan jail. Her own actions in this regard seem not of this world—or, more accurately, they are in the world but not of it. The self, in other words, is told, and lived, as a story. (Lambert can seem in this regard the perfect correspondent for the thieves-in-the-law in *The Mark of Cain*: as much as these prisoners are totally—and horribly—rooted in real life, they seek to make themselves the stuff of myth, their every tattoo offering the possibility of Odysseus's scar.) Lambert's work can occasionally even seem like hearsay and rumor. Whereas other similar artistic practices today function as documentary, and whereas others seem rooted in a decades-old indoor-outdoor dialectic—both of these approaches providing clear evidence of actions undertaken in the world, brought back into the gallery context—Lambert's engagements are more fleeting in their representation. A modest pair of flight goggles may appear in an art gallery under Plexiglas; a portion of *The Mark of Cain* airs on *Nightline*; her time among surfers results in a short portrait finding its way onto PBS; a marriage and a divorce are evidenced merely by two certificates. In all these cases, the aesthetic is that of the relic, or of the trace. For the experience represented would seem somehow beside the point in Lambert's work. In fact, it is not the work at all. And in this way Lambert's practice seems to be one of parables: her work unfolds in the distance between experience and representation, and to close that distance would be to destroy the actual work, in all its inscrutability. One would perhaps win in aesthetics, but only at the risk of losing a sense of life.

Tim Griffin is editor of Artforum International. *His book* Contamination, *a collaboration with artist Peter Halley, appeared in 2002.*

I.
MINIATURES
[1991]

I commissioned the artist Kristine Ebert to paint portraits of me on the head of a pin, a grain of rice, the head of a match, and various other tiny, tiny things. At the time, a number of artists (Jeff Koons is the prime example) were representing themselves in high-production, large-scale works, and I was interested in doing the opposite. Most of the pieces were kept in the gallery's back office. The only piece installed in the gallery space was the pin, stuck into a wall. There was no indication as to where it was, so the space looked empty. Most people walked in, looked around in vain, and then left, perplexed.

Above, fingernail clipping. Left, matchbook.

Above, postage stamp and detail. Right, film canister. The film contains a series of self-portraits, but in order to see them one would have to develop the roll, thus losing the painting.

mm Film
Color Slides

DX

EN 36 • 100/21°

EN 36 EXP.

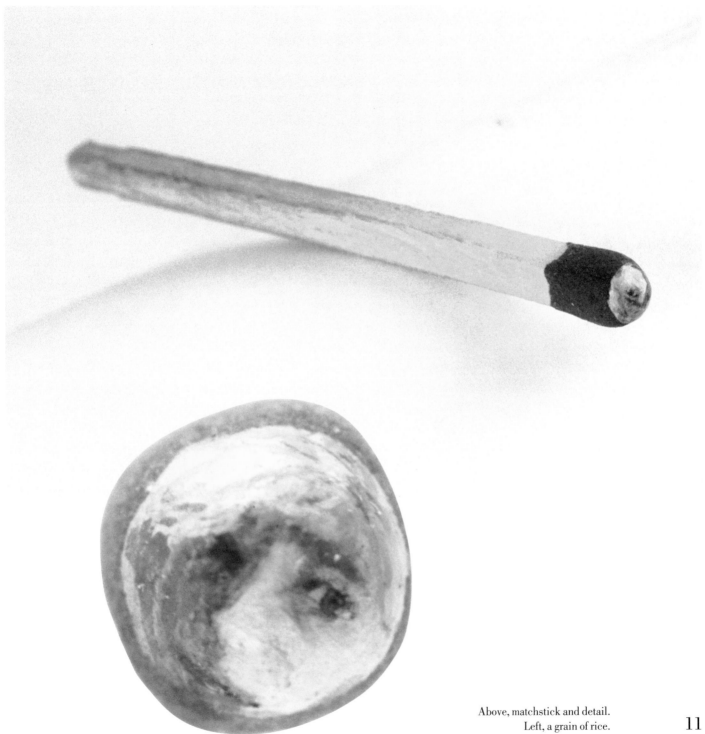

Above, matchstick and detail.
Left, a grain of rice.

11

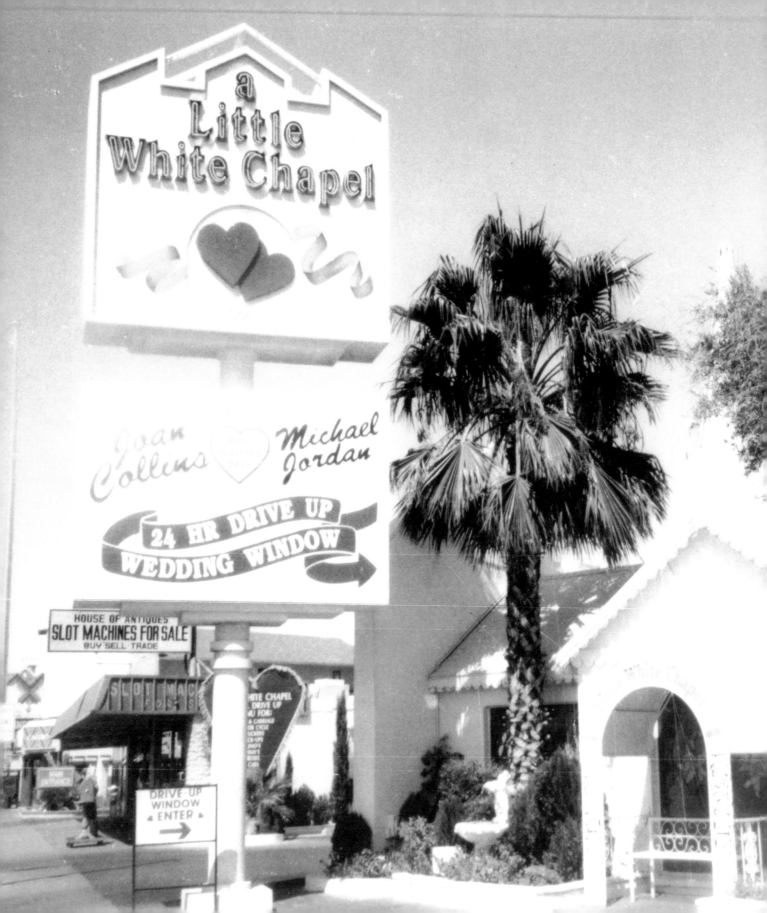

II.
THE MARRIAGE PROJECT

[1992–1993]

I got the initial idea when I was in Las Vegas and I noticed the divorce building was next to a wedding chapel. I wondered how many times you could get married and divorced in a day. In fact, after applying for a marriage license you have to wait twenty-four hours to get married. Divorcing someone, even in the fastest way, takes three to four weeks. In the span of six months, I married and divorced three men and one woman.

M92205110

License

M920

Certificate of Marriage Registration

This Is To Certify That Michael Edward Slimmer

ing at 325 West 71 St., 6E, New York, N.Y. 10023

on August 24, 1969 at New York, N.Y. USA

Alix Stewart Lambert

ing at 350 Manhattan Ave., Brooklyn, New York 11211

on July 10, 1968 at Washington, D.C. USA

Were Married

May 27, 1992 at MANHATTAN
 1 CENTRE STREET, NEW YORK

hown by the duly registered license and certificate of marriage of said persons on file in this office.

CERTIFIED THIS DATE AT THE CITY CLERK'S OFFICE

MANHATTAN N.Y. May 27, 19 92

E NOTE: Facsimile Signature
 are printed pursuant
on 11-A, Domestic
s Law of New York.

Carlos Cuevas
City Clerk of the City of N

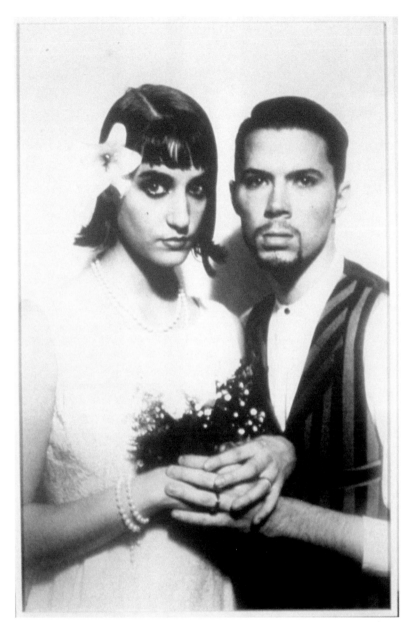

MICHAEL SLIMMER
[NEW YORK, MAY 27, 1992]

Michael was a friend who worked as a waiter at the Empire Diner. We were married at the New York City courthouse on his lunch break. At the time divorces were recorded by hand in big ledger books, which I thought was sort of archaic and beautiful. Our divorce is filed that way at the City's House of Records.

15

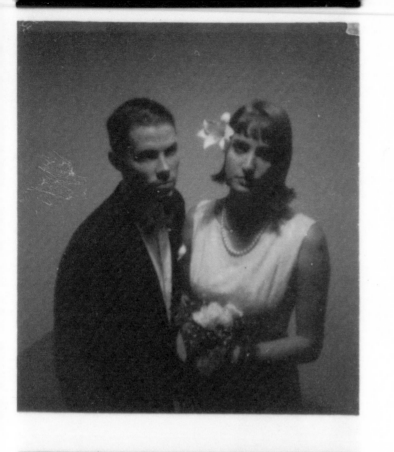

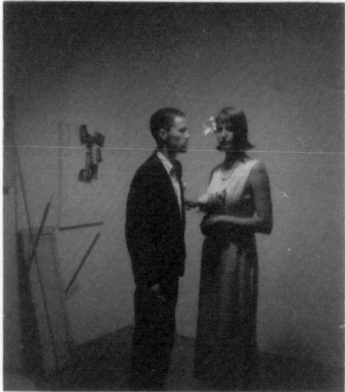
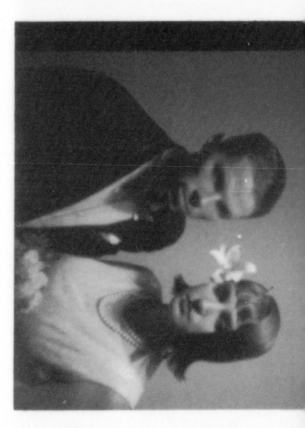

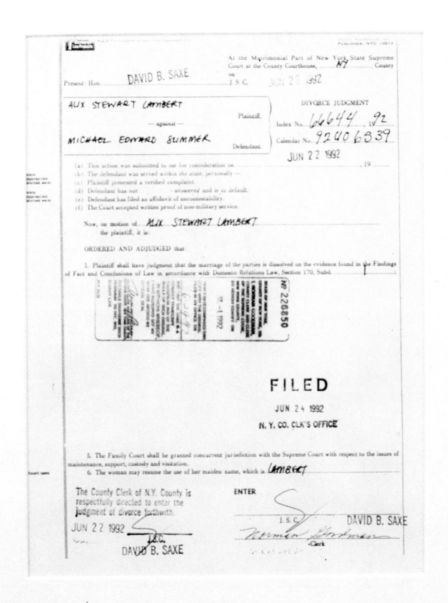

At the Matrimonial Part of New York State Supreme Court at the County Courthouse, **NY** County

Present: Hon. DAVID B. SAXE

on

J.S.C. JUN 22 1992

ALIX STEWART LAMBERT

Plaintiff.

— against —

MICHAEL EDWARD SUMMER

Defendant.

DIVORCE JUDGMENT

Index No. 66644 92

Calendar No. 92406839

JUN 22 1992

(a) This action was submitted to me for consideration on _____, 19__
(b) The defendant was served within the state, personally —
(c) Plaintiff presented a verified complaint.
(d) Defendant has not _____ answered and is in default.
(e) Defendant has filed an affidavit of uncontestability.
(f) The Court accepted written proof of non-military service.

Now, on motion of ALIX STEWART LAMBERT

the plaintiff, it is:

ORDERED AND ADJUDGED that:

1. Plaintiff shall have judgment that the marriage of the parties is dissolved on the evidence found in the Findings of Fact and Conclusions of Law in accordance with Domestic Relations Law, Section 170, Subd. _____

FILED

JUN 24 1992

N. Y. CO. CLK'S OFFICE

5. The Family Court shall be granted concurrent jurisdiction with the Supreme Court with respect to the issues of maintenance, support, custody and visitation.

6. The woman may resume the use of her maiden name, which is **LAMBERT**

The County Clerk of N.Y. County is respectfully directed to enter the judgment of divorce forthwith.

JUN 22 1992

J.S.C.

DAVID B. SAXE

ENTER

J.S.C. DAVID B. SAXE

Clerk

17

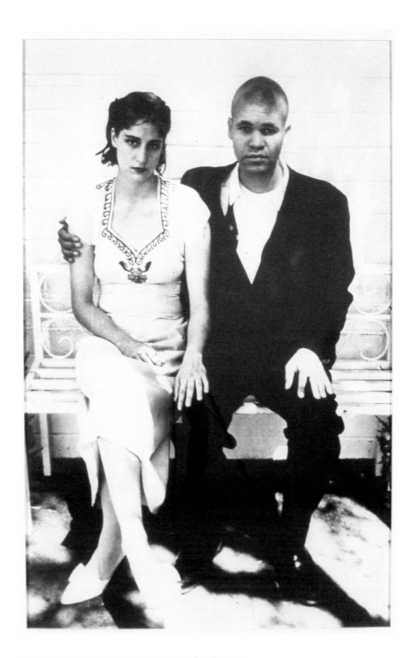

MIKE MATTISON

[LAS VEGAS, JULY 27, 1992]

We had just gotten married when we met a British filmmaker at a party who was working on a documentary about interracial marriage in America. He didn't know our marriage was an art project, so he asked if he could interview us. He showed up with a cameraman the next day. I let Michael do most of the talking.

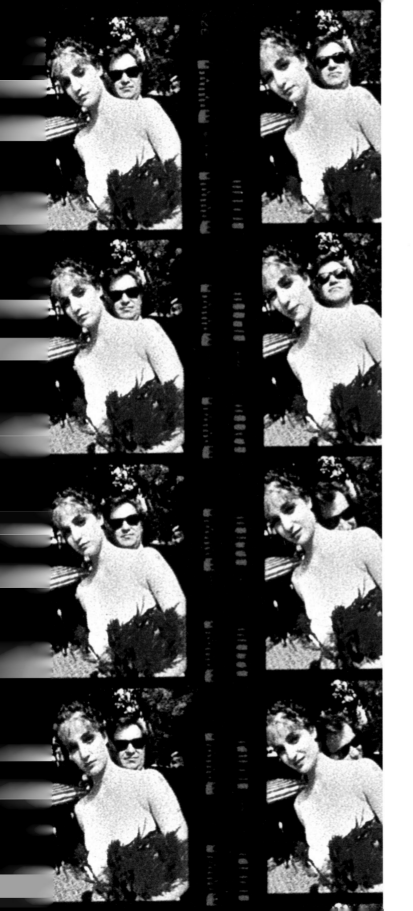

OLIVIER MOSSET
[LOS ANGELES, AUGUST 1992]

My friend Olivier was already married but in the process of getting divorced. We decided to take some engagement photos at the Chateau Marmont. Then we found out that his divorce wasn't going to be finished in time. Olivier said, "Why don't you marry my friend Bob Nickas instead?" And I did.

23

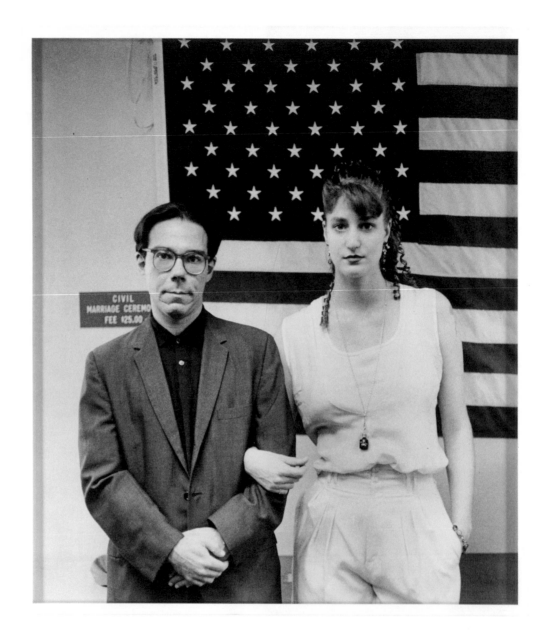

ROBERT NICKAS
[NEW YORK, OCTOBER 2, 1992]

This was at the New York City courthouse, again. Bob was the person I knew the least. The same clerk who married Michael Slimmer and me married Bob and me. Of course he didn't recognize me.

24

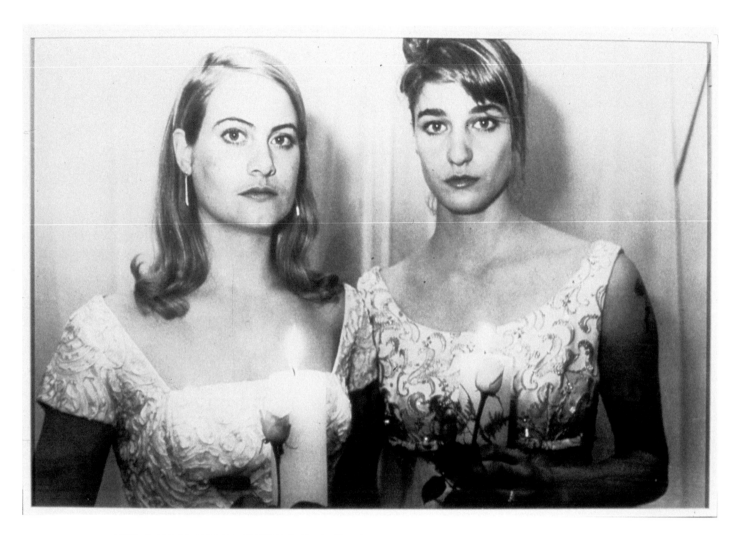

HADLEY KINCADE
[BUDAPEST, DECEMBER 18, 1992]

I went to high school with Hadley. At the time, the only place same-sex marriages were legal was Denmark, but you had to marry a Danish citizen. Hadley and I decided to have a legal domestic partnership agreement drawn up by a British lawyer. The wedding ceremony and celebration were in Budapest, Hungary, where Hadley was living.

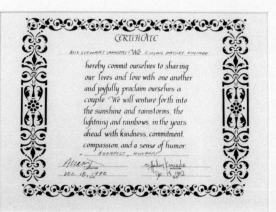

CERTIFICATE

ALIX STEWART LAMBERT We *SUSAN HADLEY KINCADE*

hereby commit ourselves to sharing
our lives and love with one another
and joyfully proclaim ourselves a
couple. We will venture forth into
the sunshine and rainstorms, the
lightning and rainbows, in the years
ahead with kindness, commitment,
compassion, and a sense of humor.
BUDAPEST, HUNGARY

Alix Lambert — SIGNATURE
DEC. 18, 1992

S. Hadley Kincade — SIGNATURE
Dec 18, 1992

S. Hadley Kincade
Also Erdösor 10
1074 Budapest

Alix Lambert
350 Manhattan Ave
Brooklyn, NY

January 17, 1993

Dear Alix,

This letter is to inform you that I would like to cancel our agreement signed on the 18th of December 1992. One week after receipt of this letter our contract should be considered null and void.

Due to reasons of emotional distress caused by distance, I feel the cancellation of our contract is the only alternative.

Sincerely,

S. Hadley Kincade
S. Hadley Kincade

LIVING-TOGETHER AGREEMENT:
KEEPING THINGS SEPARATE

We, *ALIX STEWART LAMBERT* and *SUSAN HADLEY KINCADE*
agree as follows:

1. This contract sets forth our rights and obligations toward each other, which we intend to abide by in the spirit of joy, cooperation and good faith.

2. We agree that all property owned by either one of us as of the date of this agreement shall remain separate property and cannot be transferred to the other unless done by writing. We have attached a list of our major items of separate property.

3. The income of each person, as well as any accumulations of property from that income, belongs absolutely to the person who earns the money.

4. We shall keep our own bank accounts, credit accounts, etc., and neither is in any responsible for the debts of the other.

5. Living expenses, which include groceries, utilities, rent, day-to-day expenses, shall be equally divided.

6. We may from time to time decide to keep a joint checking or savings account for some specific purpose, or to own some property jointly. Any joint ownership shall be reflected in writing or shall be reflected on the ownership document of the property. If we fail to otherwise provide in writing for the disposition of our jointly owned property should we separate, we agree to divide the jointly held property equally. Such agreements aren't to be interpreted as creating an implication that other property is jointly owned.

7. Should either of us receive real or personal property by gift or inheritance, the property belongs absolutely to the person receiving the gift or inheritance and cannot be transferred to the other except by writing.

8. We agree that neither of us shall have any rights to, or financial interest in, any separate real property of the other, whether obtained before or after the date of this contract, unless that right or interest is in writing.

9. Either one of us may terminate this contract by giving the other a one-week written notice. In the event either of us is seriously considering leaving or ending the relationship, that person shall take at least a three-day vacation from the relationship. We also agree to at least one counseling session if either one of us requests it.

10. In the event that we separate, all jointly owned property shall be divided equally, and neither of us shall have any claim for support or for any other money or property from the other.

11. We agree that any dispute arising out of this contract shall be mediated by a third person mutually acceptable to both of us. The mediator's role shall be to help us arrive at our own solution, not to impose one on us. If good faith efforts to arrive at our own solution to all issues in dispute with the help of a mediation prove to be fruitless, either of us may:

(1) initiate arbitration by making a written demand for arbitration, defining the dispute and naming one arbitrator, (2) within five days from receipt of this notice, the other shall name the second arbitrator, (3) the two named arbitrators shall within ten days name a third arbitrator, (4) within seven days an arbitration meeting will be held. Each of us may have counsel if we choose, and may present evidence and witnesses pertinent; (5) the arbitrators shall make their decision within five days after the hearing. Their decision shall be in writing and shall be binding upon us; (6) if the person to whom the demand for arbitration is directed fails to respond within five days, the other must give an additional five days' written notice of his or her intent to proceed. If there's no response, the person initiating the arbitration may proceed with the arbitration before the arbitrator he or she has designated, and his/her award shall have the same force as if it had been settled by all three arbitrators.

12. This agreement represents our complete understanding regarding our living together and replaces any and all prior agreements, written or oral. It can be amended, but only in writing, and must be signed by both of us.

13. We agree that if a court finds any portion of this contract to be illegal or otherwise unenforceable, the remainder of the contract is still in full force and effect.

Signed this *18* day of *DEC 92* at *BUDAPEST, HUNGARY*

Alix Lambert
(Signature)

S. Hadley Kincade
(Signature)

A couple of Hadley's photographer friends took pictures of the ceremony for me to exhibit. Hadley and I went to Poland for our honeymoon, and we saw the newspapers as soon as we got off the train back in Budapest. The photographers had sold some of their photos to local papers. The *Magyar Narancs*, which is the Hungarian equivalent of the *Village Voice*, put us on the cover. I wanted to buy more copies, but they were all sold out. They said it was the first time the paper had ever sold out. Hadley was invited to be on a morning TV show where they interviewed her and asked people in the street what they thought of marriage and divorce.

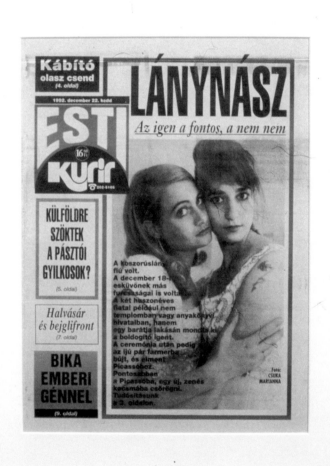

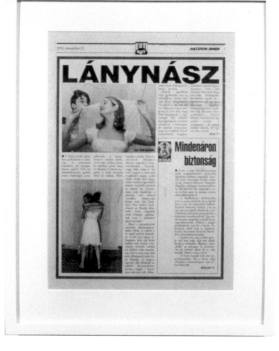

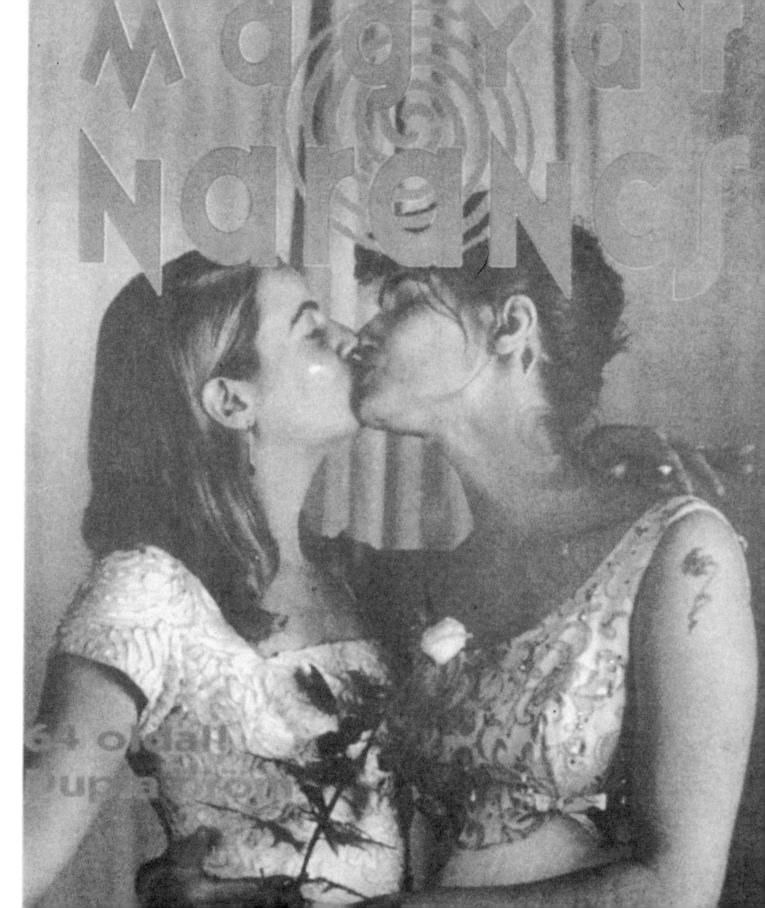

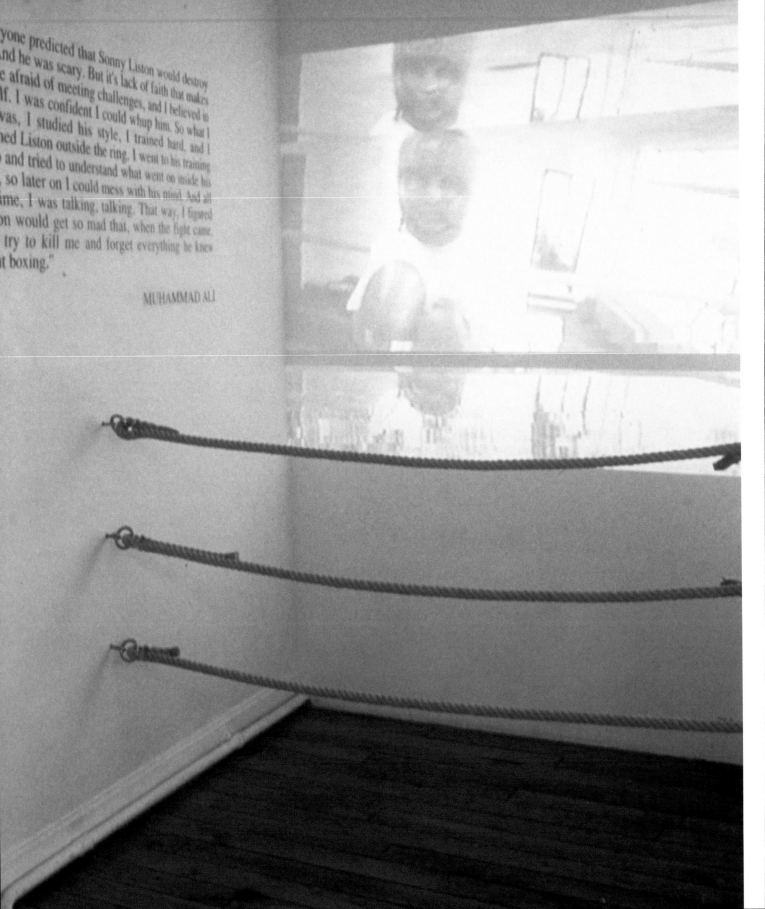

...yone predicted that Sonny Liston would destroy ...and he was scary. But it's lack of faith that makes ...e afraid of meeting challenges, and I believed in ...lf. I was confident I could whup him. So what I ...was, I studied his style, I trained hard, and I ...ned Liston outside the ring. I went to his training ...p and tried to understand what went on inside his ..., so later on I could mess with his mind. And at ...me, I was talking, talking. That way, I figured ...on would get so mad that, when the fight came, ... try to kill me and forget everything he knew ...t boxing."

MUHAMMAD ALI

III.
KINGSWAY TRILOGY
[1994]

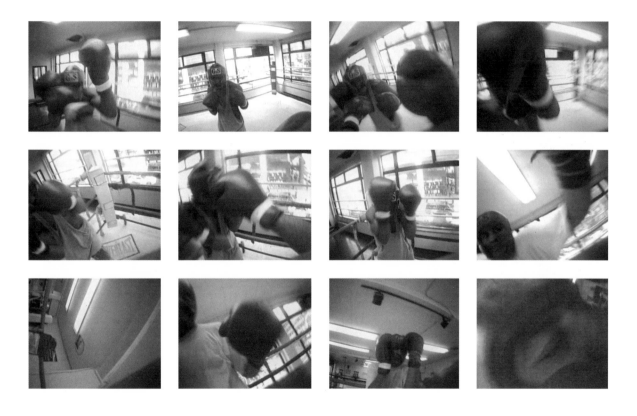

I had taken up boxing. I liked that it was a whole world, and I was actually good at it. The Kingsway gym was on Fortieth Street and Eighth Avenue in the old Times Square. Boxing is great looking; it's so cinematic. I got a lipstick camera and attached it to the headgear and gloves of two boxers. The video is in three parts, each lasting three minutes, which is the length of a boxing round. The first part is the point of view of one boxer, the second is the point of view of the other, and the third is the image breaking down because the camera is being hit so relentlessly.

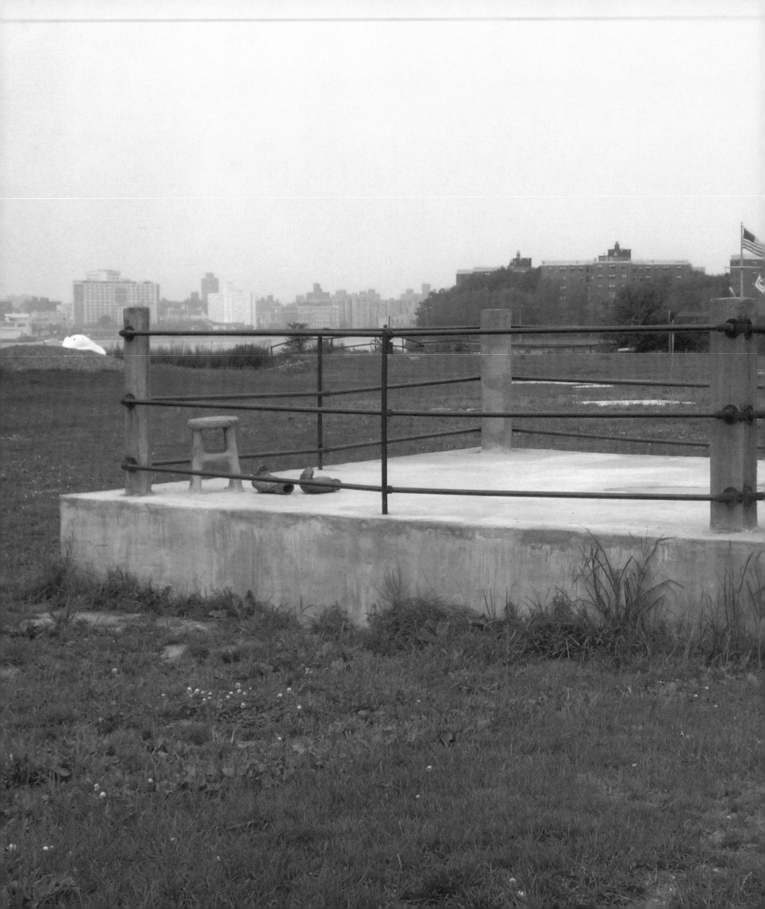

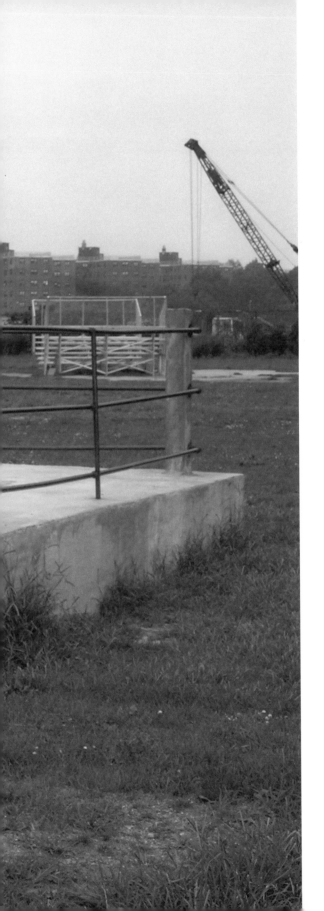

IV.
WILD CARD

[2005]

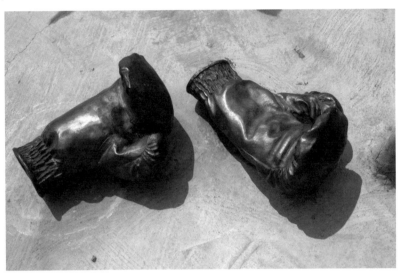

I like the aesthetics of the ring, all the accoutrements. This is a full-size boxing ring installed at Socrates Sculpture Park in Queens, New York. The ring is cast out of cement with metal piping used as ropes, a pair of bronze-cast boxing gloves, and a cement corner stool.

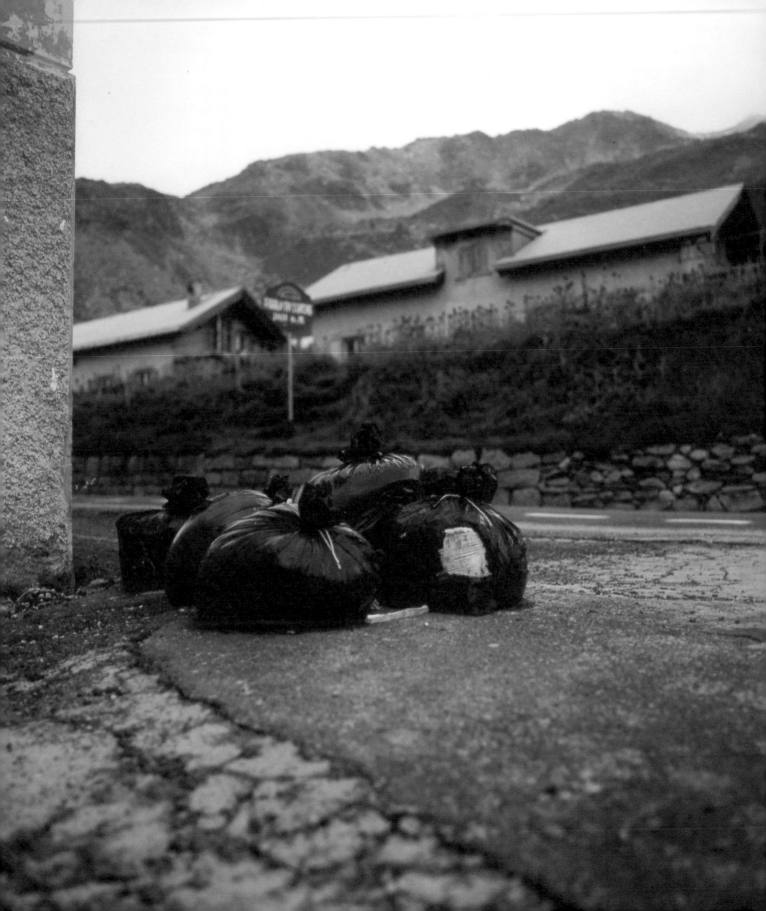

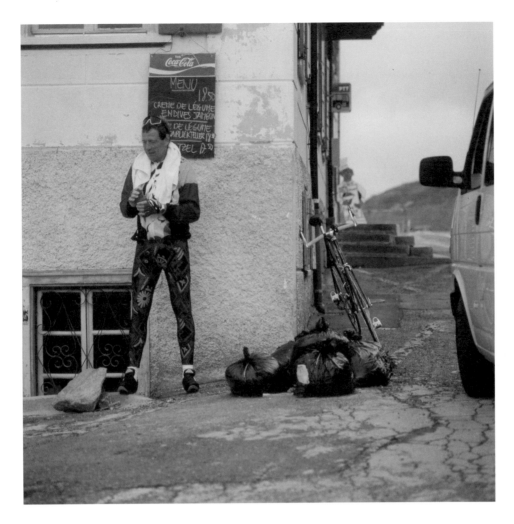

V.
FURKAPASS

[1993]

Mark Hostetler, who owns a hotel in the Swiss Alps, invites artists to stay there and create
site-specific pieces. When I was there I felt that trying to compete with the Alps was a
thankless task, so I filled garbage bags with cement and set them outside the hotel where
the garbage got collected. This caused confusion among hotel guests and garbagemen alike.
The bags were biodegradable, so by now the installation is an abstract cement sculpture.

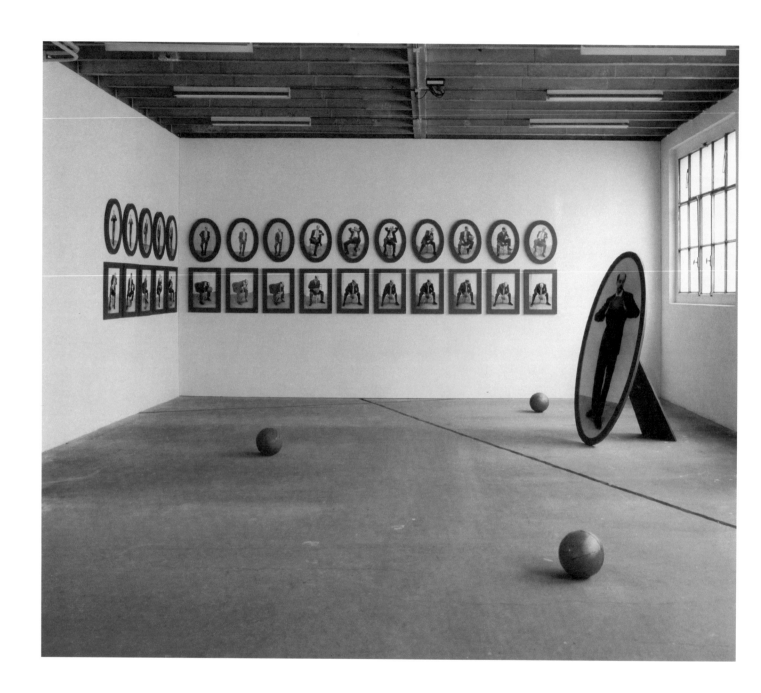

36

VI.
MALE PATTERN BALDNESS

[1993–1994]

On a whim, I shaved my head like a balding man. I put on a suit to complete the picture. Once I started holding the basketball, it gave this bald man the personality of a coach. After the pictures were taken, I noticed that the images looked like a Muybridge of a basketball coach.

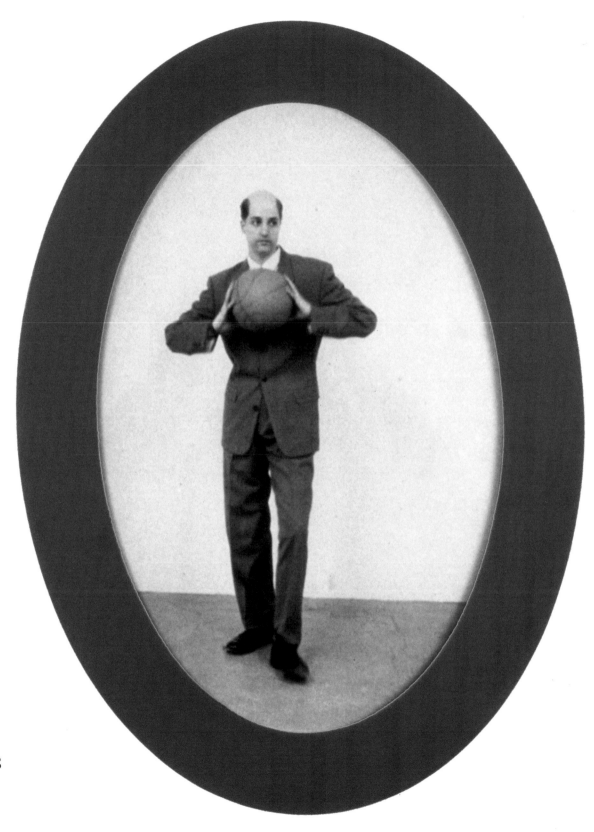

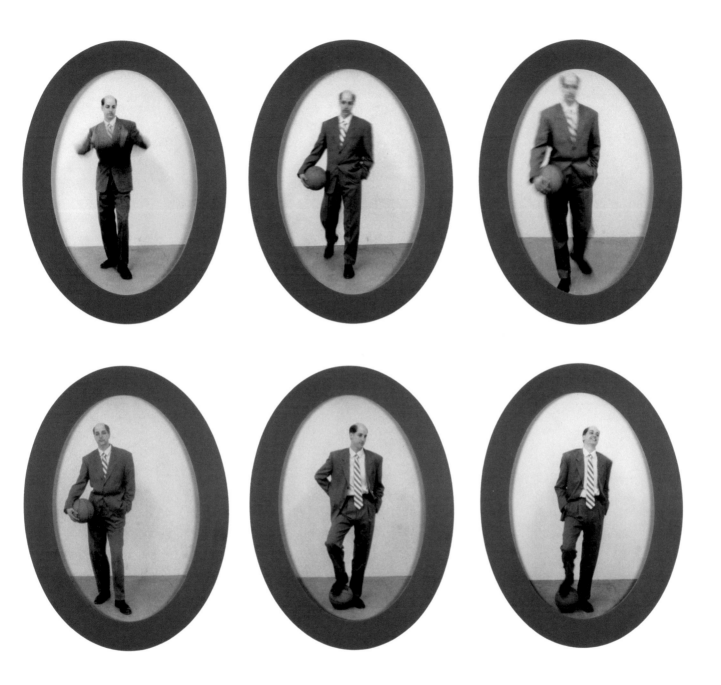

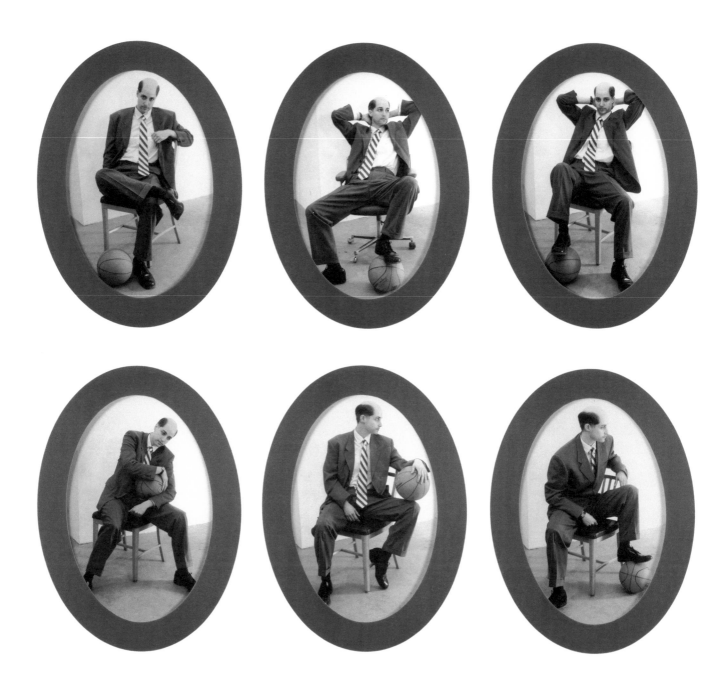

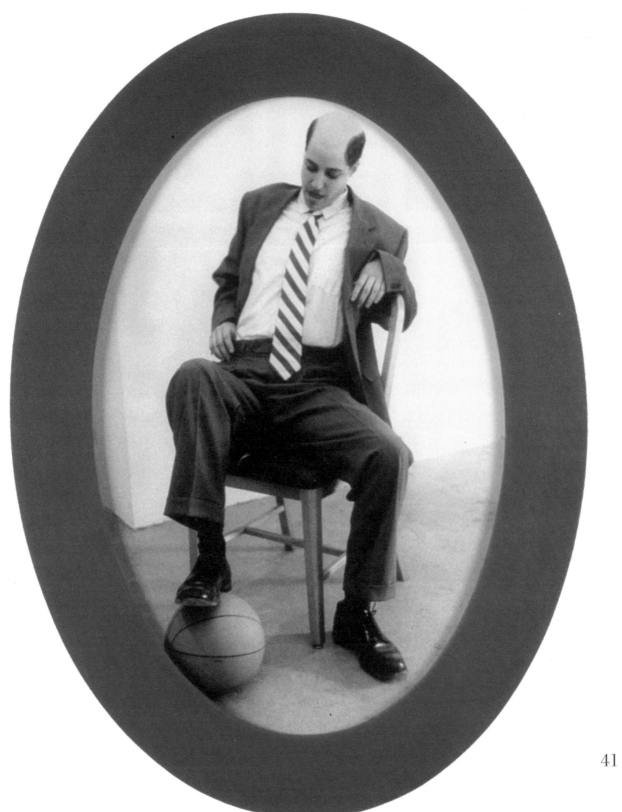

41

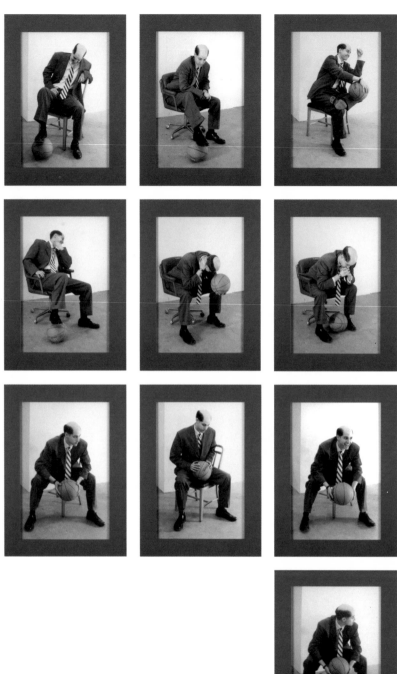
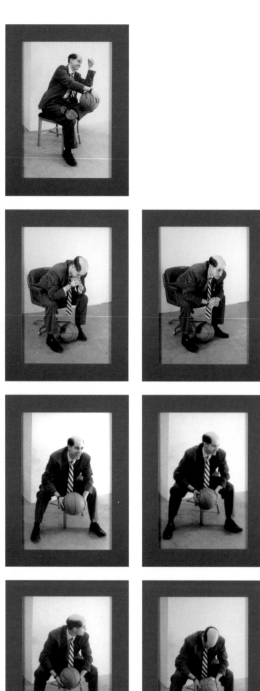
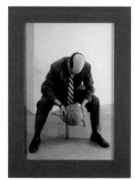

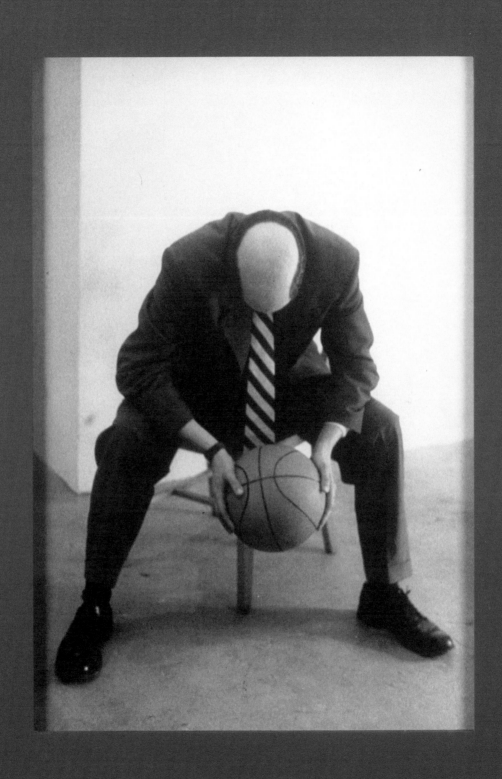

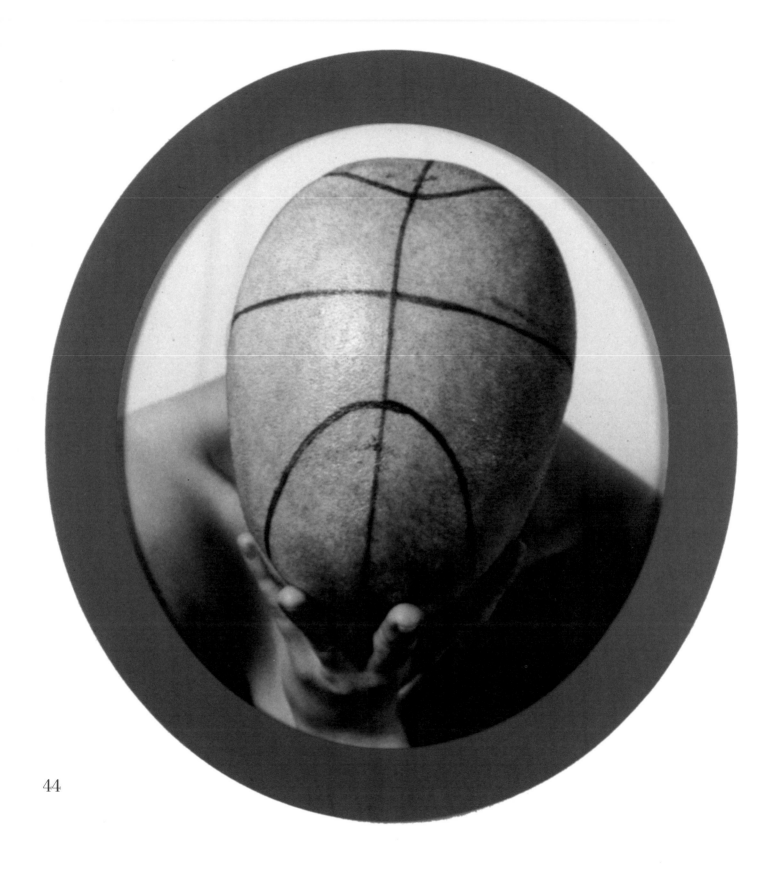

44

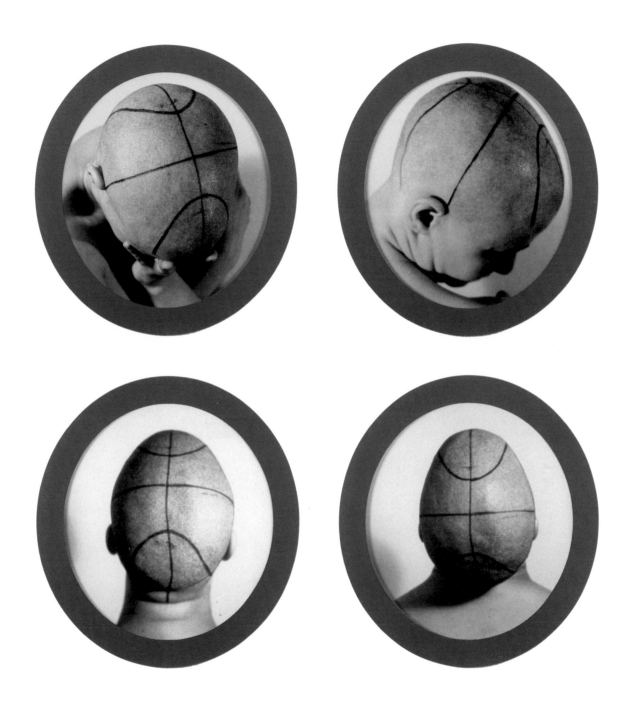

I shaved the rest of my hair off a couple of days after I took the original photos and drew the lines of the ball on my head with eyeliner.

45

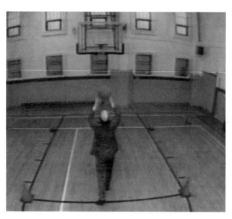 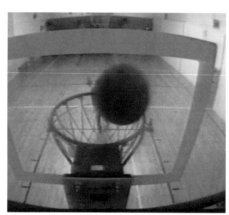 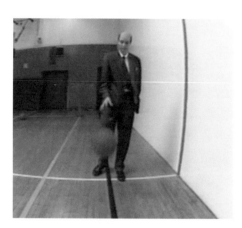

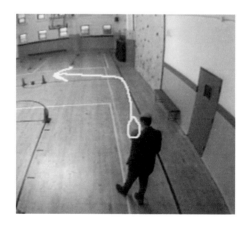 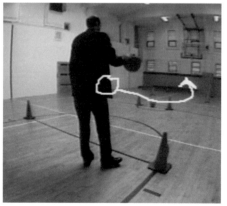 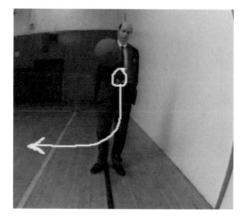

　Stills from the video *Male Pattern Baldness*.

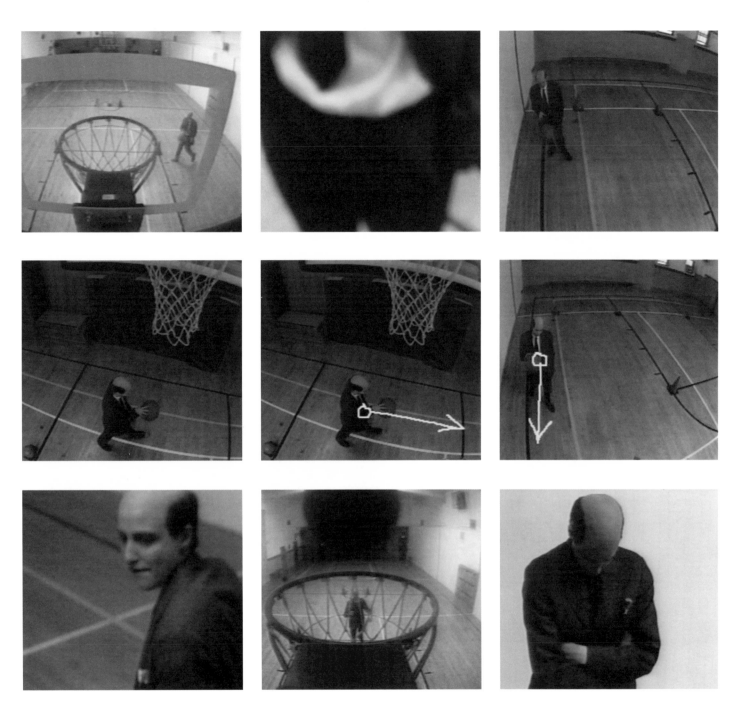

A year later, a curator asked me if the project had a video component
that could be included in a show in Japan. There wasn't, but I said that
there was, which meant that I had to shave my head all over again.

VII.
PLATIPUSSY

[1996]

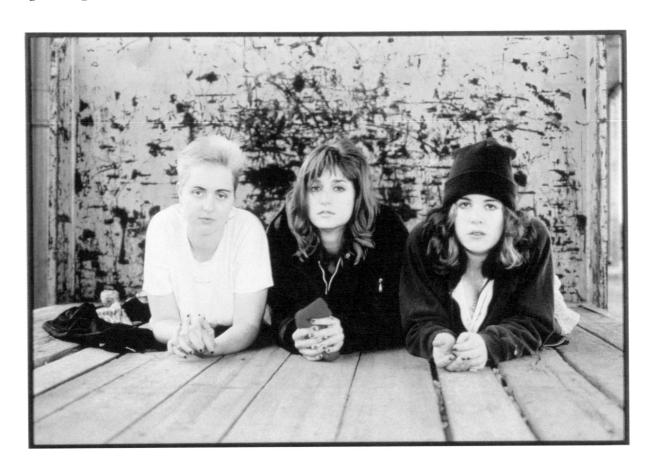

Alyssa Sarfity, Juliette Goodwin, and I formed a girl band. We were bad on purpose. It was a reaction to the grunge/ postpunk/riot-grrl bands that were getting so much attention at the time. I played the drums, Julie played bass, and Alyssa played guitar. Julie did most of the singing. But we didn't spend a huge amount of time trying to be accurate about satirizing the music. (You have to practice even to make a bad album.) I was interested in figuring out how you make band photos or T-shirts that are somehow convincing. We recorded an album, shot a movie trailer and a music video, and made a lot of merch, including panties and posters.

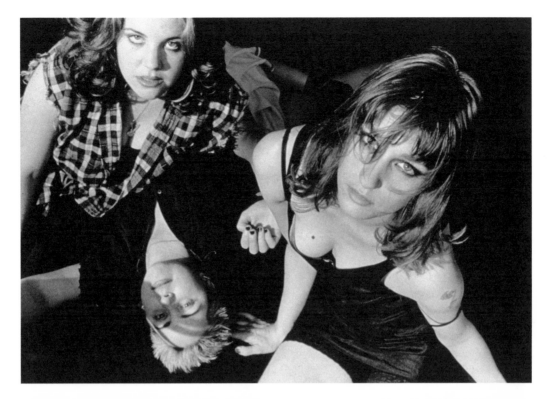

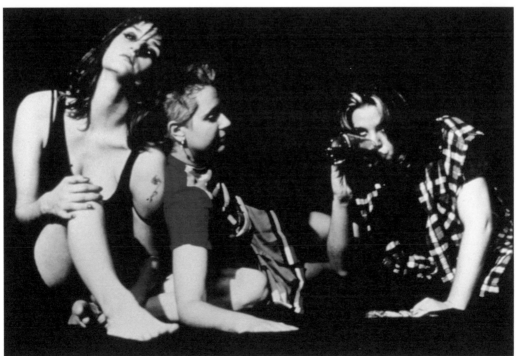

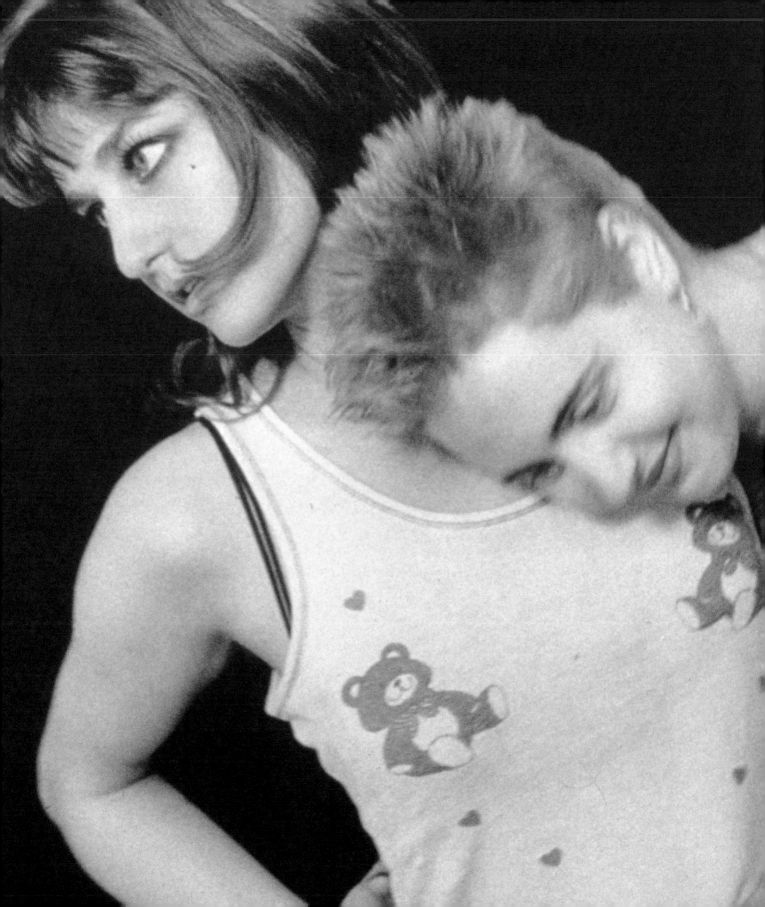

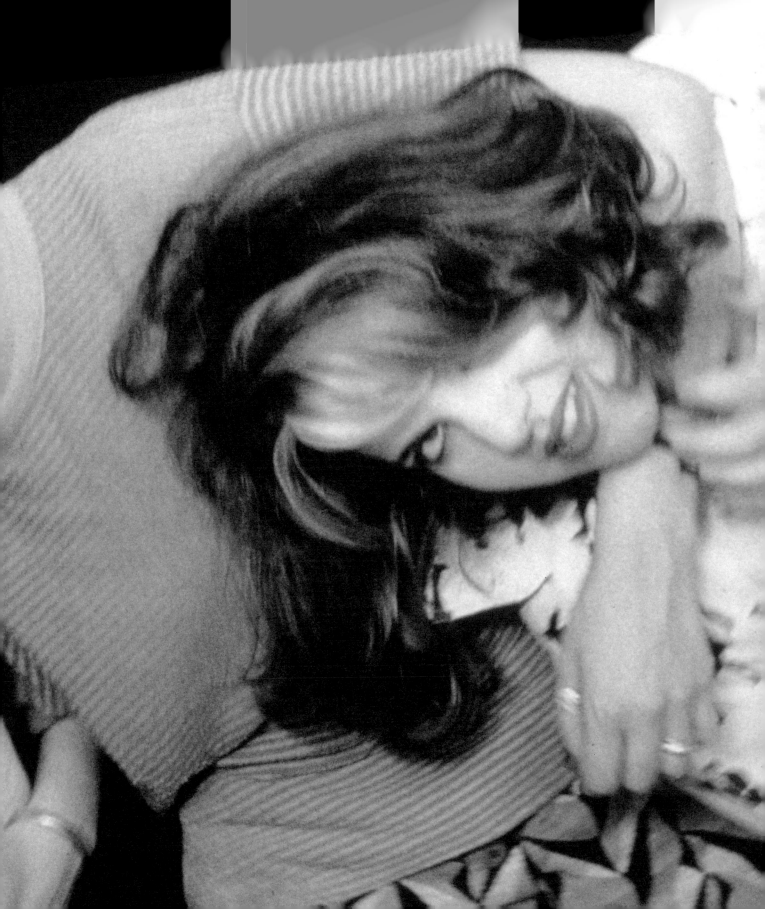

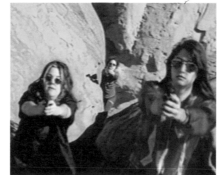

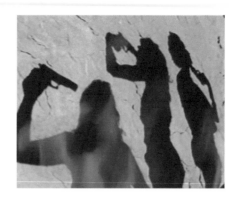

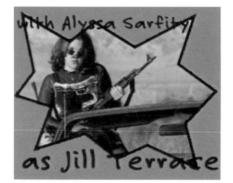

with Alyssa Sarfity

as Jill Terrace

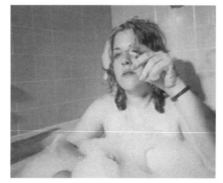

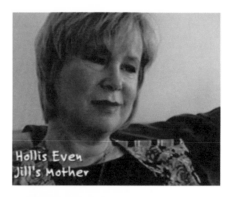

Hollis Even
Jill's Mother

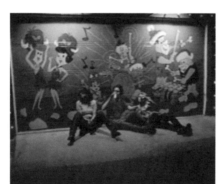

Dennis Dennehy
Platipussy's Publicist

& SUPPLIE
DRUGS
GUNS
BOOZE

Henry Holmes
Platipussy's Lawyer

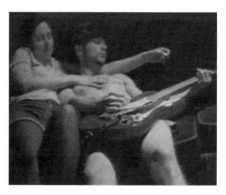

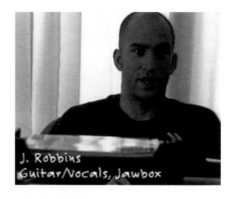

as Ginger Snap

as Stewart Newark

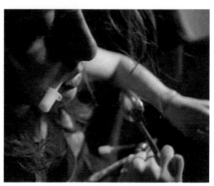

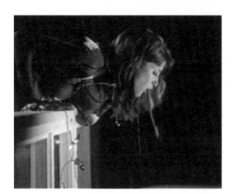

Anne Newark
Stewart's Mother

Film stills from the Platipussy trailer.

We talked to a couple of people about writing fake articles about Platipussy in real magazines, which never happened (although the Platipussy album did chart in a real fanzine), so we decided to make mock-ups ourselves.

53

$70M LOTTO FEVER!

YOUR GUIDE TO WINNING THE BIG JACKPOT: PAGES 2 & 3

NEW YORK POST

METRO EDITION

FRIDAY, MAY 30, 1997 / Partly sunny, 75 / Weather: Page 34 http://www.nypostonline.com/ · · · · 50¢

ROCK GALS SHOT DEAD

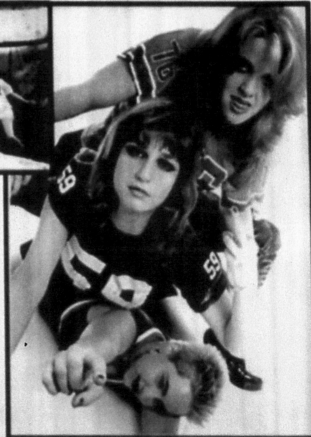

CUL-DE-SAC SLAYING SHOCKS L.A.

The death of rock's bad girls Platipussy has stumped the LAPD. "They would've had to make a U-turn," says L.A.'s Top Cop referring to Cali's favorite form of murder the "drive by."

PAGE 7

COPS PROBE DADDY'S SECRET PORN LIFE

THE NEW NATIONAL ENQUIRER

LARGEST CIRCULATION OF ANY PAPER IN AMERICA

$1.39/$1.69 CANADA

Ilyak 8, 1883

PLATIPUSSY BLOODBATH

EXCLUSIVE

Spy-Cam Captures Carnage
Bad Girls of Rock Meet
Bitter End Outside L.A. Compound
Suspects Abound

COLLECTOR'S EDITION

Top Brass Revealed
in Navy Sex Scandal
-excusive photos inside

THE OSCARS
— the fashions
and the gossip from
H'wood's hottest night!

98100

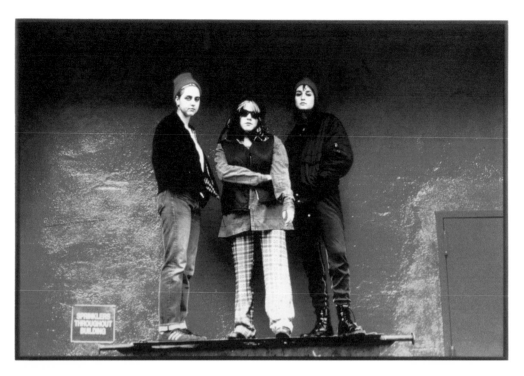

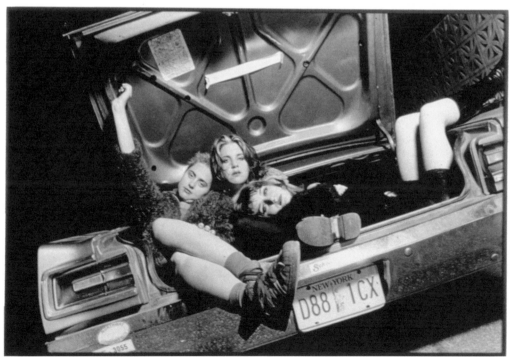

56

The True Story of a Fake Band

AMY KELLNER

Platipussy was an all-girl grunge trio who rose to fame in the mid-1990s, mostly due to their gimmicky use of guns onstage and off. They recorded one EP, featuring the single "Get Your Shit Outta My Place," which hit number one on the alternative charts after all three band members were found shot dead in a cul-de-sac. Authorities never found conclusive evidence as to who committed the shootings, and there is speculation as to whether it was a murder, a triple suicide, or a drunken mishap.

That's the story of Platipussy, the way it would be encapsulated in something like *The All Music Guide*. Platipussy, however, is fictional. The "fake" band is half homage and half parody, a cultural time capsule of the brief moment in the mid-'90s right before punk rock died and "girl power" went from actually meaning something to a cheesy T-shirt slogan for tweens.

After tucking four divorces and a shaved head under her belt, Alix Lambert decided she wanted to start a band. Like most parodies, Platipussy comes from a deep appreciation of the thing it's poking fun at. Growing up in Washington, DC, Lambert went to punk shows during the scene's heyday. As in her other projects, she found a way to "become" this thing, albeit from a skewed, self-aware, outsider's perspective.

Lambert's first obstacle was that she seemed to have little to no discernible musical talent. No matter. She enlisted two girlfriends to pose with her for band photos. Image

comes first, right? These photos are done in the totally clichéd publicity style, all tilted angles and either moody black-and-white or hypersaturated color. The girls pose in front of walls with peeling paint to "symbolize decay" (how punk). They are pouty and sexy yet tough and menacing—witness their sneers and their ski hats.

Having worked as a rock critic in the '90s, I wouldn't have even blinked at these photos, so generic they are. "Oh great, another Babes in Toyland–wannabe band," I might have thought, before tossing the press packet in the garbage. (I was a bitter, jaded rock critic. But what rock critic isn't?) However, one photo is a giveaway—the one where the girls look moodily out at us from inside a car trunk. At first glance, you're, like, whatever, a Seattle-style grunge band being all tough with the "mechanic chic." But then if you think about it, they're *stuffed into a car trunk*. It's a parody of the "tough guy" grunge aesthetic. You have all the signifiers of toughness—the slouchy posture, the withering gaze, the big car—but it's just a little bit off, just a smidge too absurd to be real. And totally fucking funny.

Pleased with her band photos, Lambert decided to make an entire faux documentary about her new faux band. However, in order to do so, they would have to actually record some music and make some videos that could be featured in the documentary. So in order to make a documentary about a fake band, the fake band became a real band. "It wasn't that much of a stretch," says Lambert. "We were basically living like a band anyway. We were broke, living in squalor, and we drank a lot." Lambert took exactly two drum lessons, wrote a few songs, recorded them with her bandmates (who already knew how to play their instruments—enough), and filmed a video. That sounds pretty "real," doesn't it?

The only "real" thing they didn't do was play shows. But that also fits Platipussy's elaborate mythology. Lambert says, "Platipussy didn't play shows because they were too fucked up all the time," a story line that dovetails nicely with the band members' very limited musical expertise. Still, Lambert says that, years later, people have insisted that they saw her band play live. They've even told her where they've seen her.

The songs that Platipussy recorded are … well, let's just say they are technically poor. Not quite Shaggs-level poor (where poor goes full circle into genius) but just … not good. But who cares? This was the '90s, when the riot-grrl ethos encouraged girls to pick up instruments and just make it up as they went along—and it was awesome! It was uncool to sound too slick, and sloppiness was a sign of authenticity. Ideas and passion trumped technical proficiency. And in the case of Platipussy, their ideas and passions were conveyed in songs like "Eat Me." But Platipussy's songs don't sound much suckier than half of what came out on popular indie/riot-grrl labels like Kill Rock Stars or K Records in the mid-'90s. The songs are full of sludgy bass, off-key screaming, and maniacal laughter. I would totally have played them on my college radio show, in between Bratmobile and L7.

The music video for the instrumental track entitled "Bond Related Noise" would not have looked out of place on MTV's *120 Minutes*. In it, the band reenacts the iconic, gun-barrel opening sequence of James Bond films. This is interspersed with the band posing in various *Charlie's Angels*–style silhouettes in front of cheesy backgrounds like flames and trippy fractals. At the time, appropriating '70s kitsch was big with underground bands but not so much in the mainstream yet. (This was before the *Charlie's Angels* movies and the James Bond parody in *Austin Powers*.) And gun imagery was particularly big in the feminist-punk milieu. Maybe my memory exaggerates, but I feel like every riot-grrl, homopunk zine or seven-inch I ever got had clip art of guns all over it. (Well, either guns or kittens.) So the video works on two levels: as a key part of the Platipussy story—the band is obsessed with guns—and also as a parody of the gun-heavy girl-punk aesthetic of the time.

When you went to see the Platipussy exhibition, you were presented with the photo

stills, the record, the music video, some band merch (the requisite silk-screened T-shirts and underwear), and the centerpiece, which was a five-minute trailer for the Platipussy rockumentary, a *Behind the Music*–type exposé on the band, complete with teary-eyed interviews with friends and family members. The interviews are filled with typically platitude-laden sound bites. "I hate to see people eaten alive by their own ambitions," says J. Robbins of the band Jawbox—a real band that was prominent in the '90s DC postpunk scene. In another instance of the blurring between real and fake, everyone in the film plays themselves except for the band (and even they are pretty much just acting like they normally would—if they were drunk and playing with guns). Lambert says that when she interviewed her mother and her bandmates' mothers, she asked them to just talk about their real daughters' characteristics, albeit as if they were in a famous rock band.

In the trailer, we get to see the full spectrum of Platipussy's antics. There they are, chain-smoking, drinking, even shooting up. There is one shot, which is actually quite beautiful, of them puking off a balcony one after another. They carry guns everywhere—even in the bathtub. In another shot, done in the *Charlie's Angels* silhouette style, the three girls point guns first at each other's heads and then in their own mouths. It's darkly funny, and it shows the absurdity of that whole bad-girls-with-guns aesthetic. Like, is playing with guns tough? Or is it just really, really stupid?

The trailer only hints at the heinous deaths that befell Platipussy (we learn of their gruesome demise from the magazine clippings displayed on the gallery walls), but you know they have to end in a bad way. Nobody in the film even talks about their music. It's all about their wildly destructive behavior. In one way it's a parody of Courtney Love, or any celebrity whose main claim to fame is acting like a maniac. There's also a touch of Spice Girls parody in there, too. Like Platipussy, the Spice Girls relied more on hype and marketing than on actual musical talent. But Lambert isn't so much making fun of a particular band as she is making fun of the media's love of bands with sellable gimmicks—i.e., they are girls, or they are drug addicts, or they shoot guns onstage. Platipussy managed to combine punk, guns, girls, and controversy, all within the safe confines of a gallery's walls. As Lambert said, "Who wouldn't want to be in a rock band without the consequences?"

Amy Kellner is the music reviews editor and a contributing writer for Vice *magazine. Her interview with Lily van der Stokker appears in the artist's monograph* Lily van der Stokker: Friends and Family *(Les Presses du Réel, 2003).*

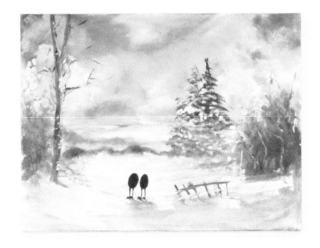

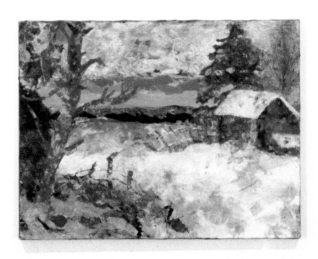

VIII.
THE
JOY OF
PAINTING

[1995]

I bought 44 instructional tapes by the painter
Bob Ross, host of the popular TV show
The Joy of Painting, and sent them out to
contemporary artists asking them to follow the
tape. I sent them canvas but no paint. Some
artists actually tried to follow the instructions
and make the painting. Others did what they
wanted; one made an animated film of Bob
watching lesbian porn on his TV, with the
theme music from his show as the soundtrack.

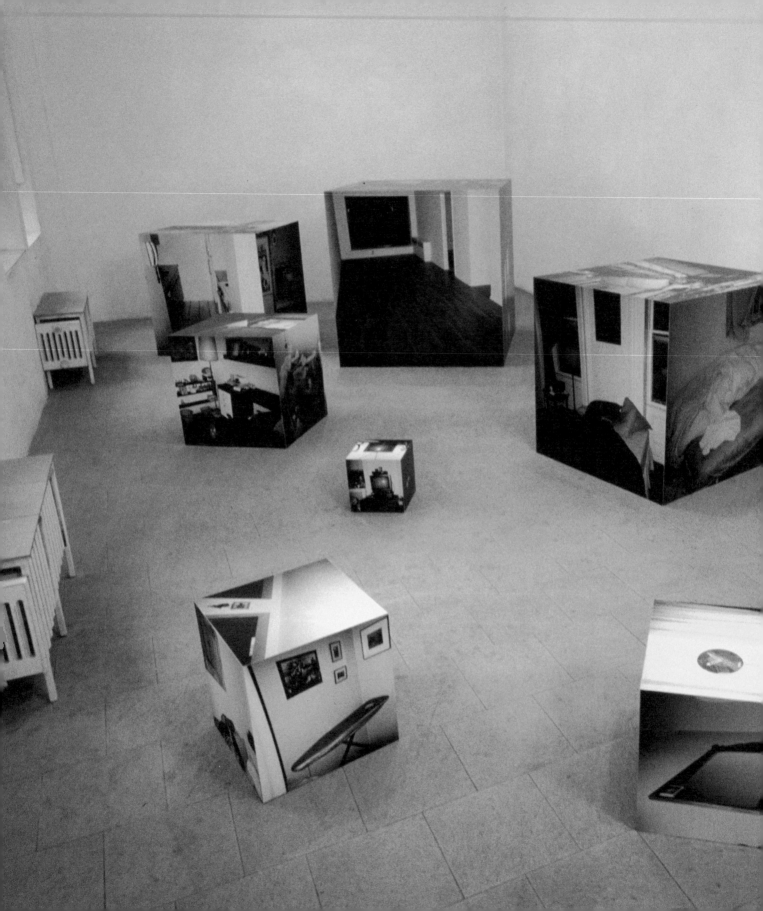

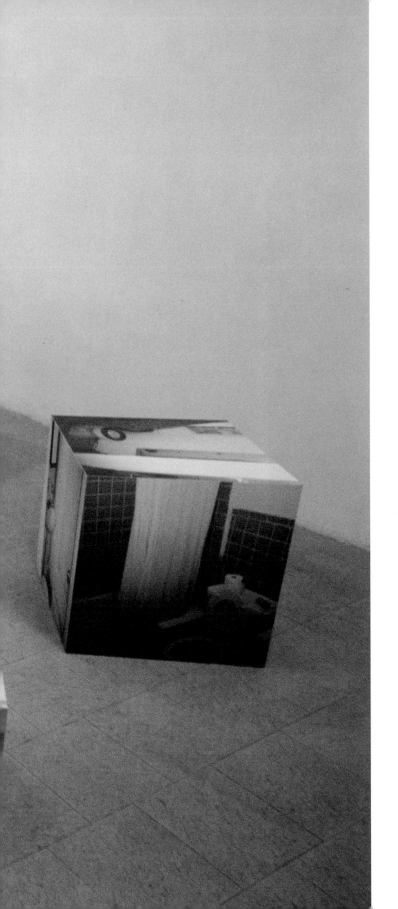

IX.
APARTMENTS
[1997]

Along with the artist Cameron Martin, I spent a few months housesitting while neither of us had a place to live. We stayed at eight different apartments over the span of two months. So much of my life at that time was about trying to find a space to live, so why not document it? We photographed the apartments with disposable cameras and then used the photos to make different-sized cubes. The large cube had images of each bedroom, the smallest cube had images of each TV. Accompanying the cubes were floor plans of each apartment drawn from memory, mine side by side with Cameron's. They were drawn six months after our stay, so our memories differed.

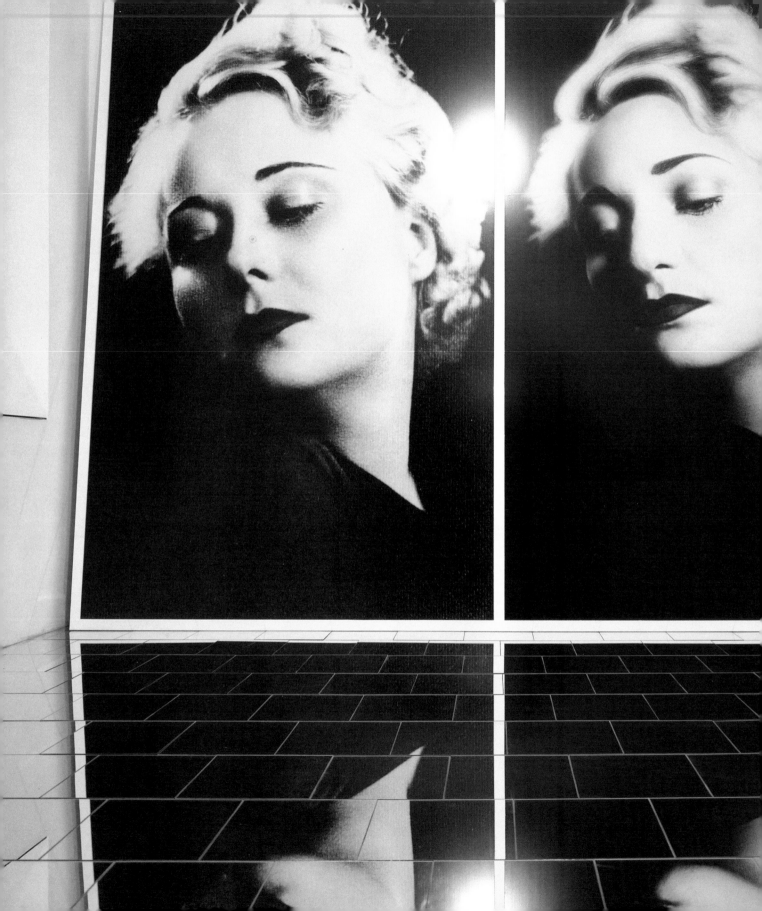

X.
ETHEL
AND ME
[1994–1997]

I found an old head shot of my grandmother;
she was 27 and interested in acting. I was
also 27, and I wanted to know how closely
one could re-create a photograph. Jill Peters
photographed me looking as much like my
grandmother as possible, although I don't
actually resemble her. We didn't use any
computer manipulation; the only artificial
adjustment was adding hair, by airbrush, since
I had really short hair at the time.

XI.
TATTOO

[1995–1998]

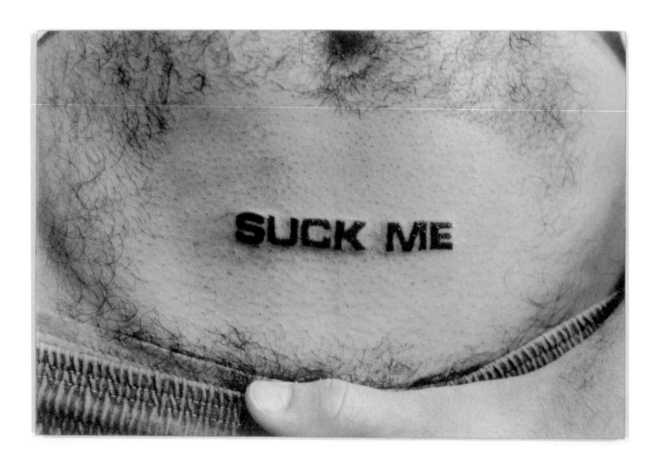

In researching my documentary on the culture of Russian prison tattoos, I learned how to tattoo. I bought a whole tattooing kit, including an autoclave, which sterilizes needles. I started with fruit, moved on to a stuffed pig and then my friends. (It's a tradition for a tattoo artist to do her first tattoo on herself. I tattooed my right pinkie toe with two black rings.) I tattooed people who either knew me or had some reason to want the experience to be personal. They chose their own images and understood that I was learning. All the tattoos were done in my apartment.

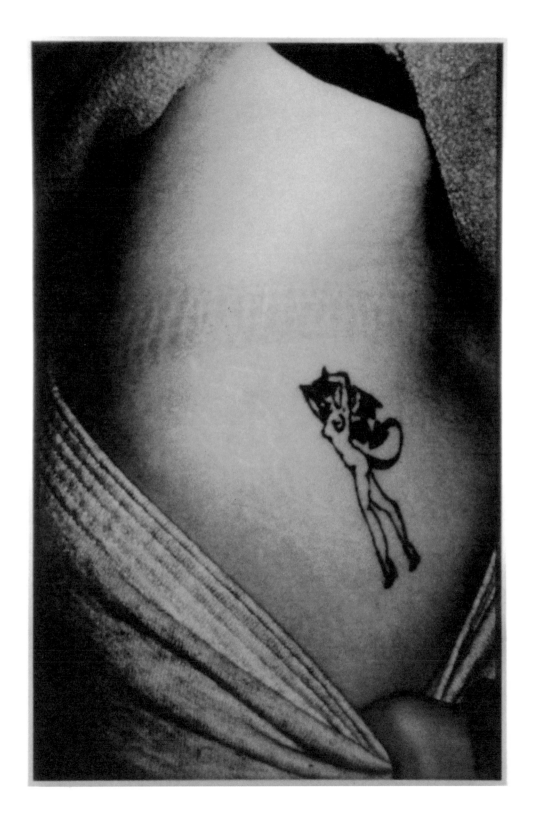

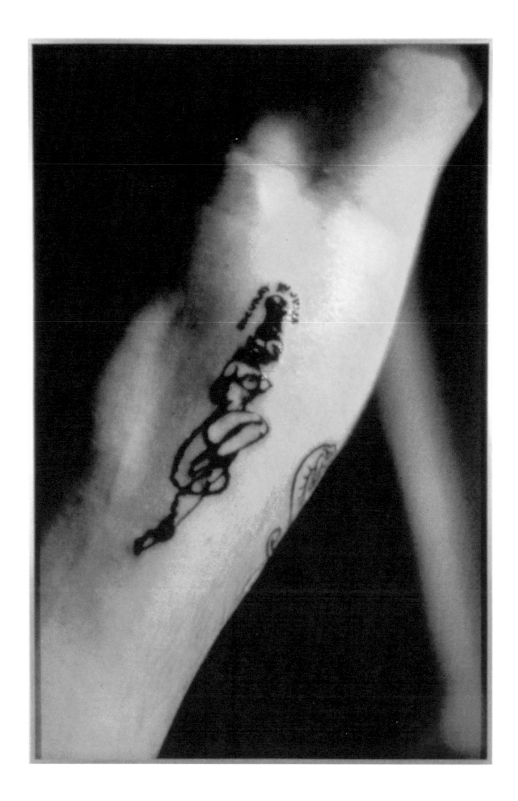

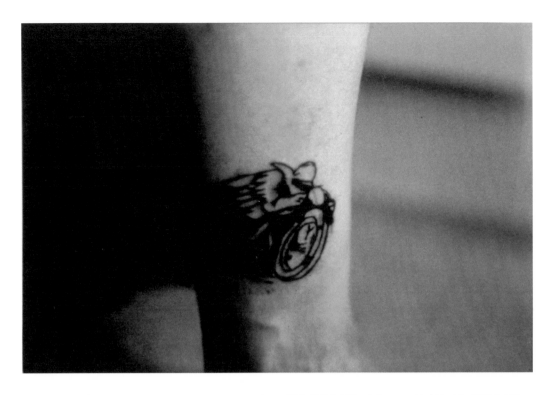

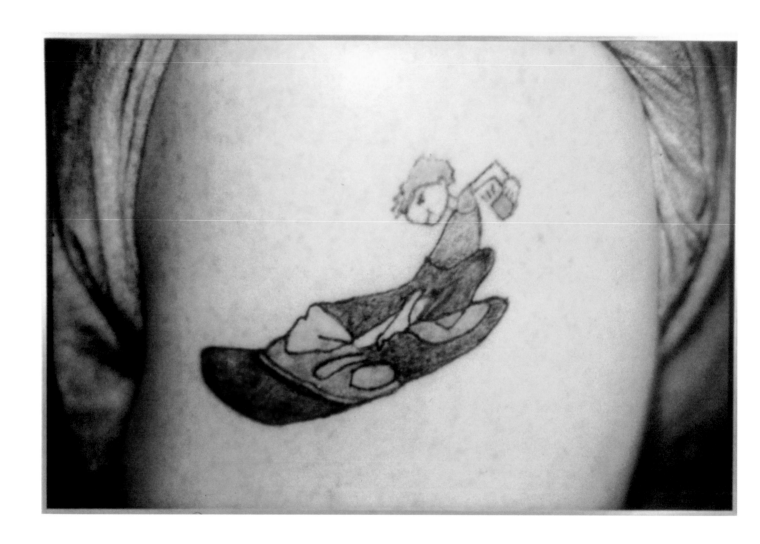

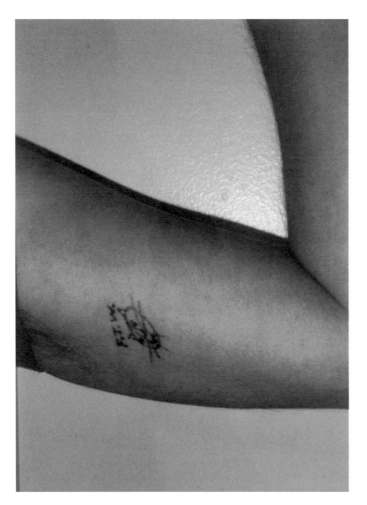

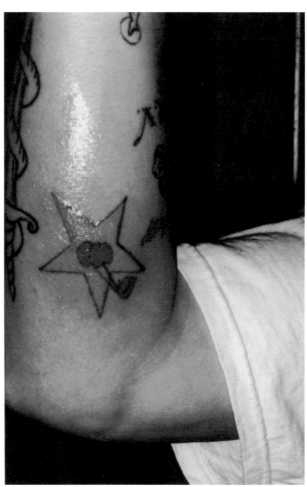

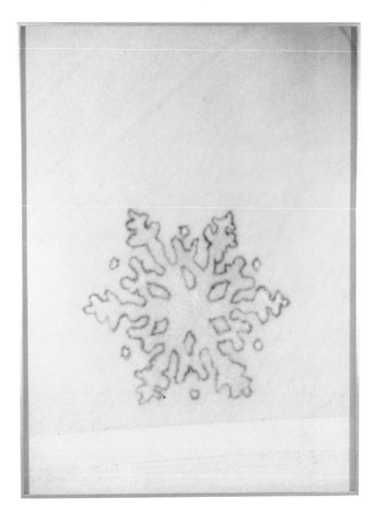

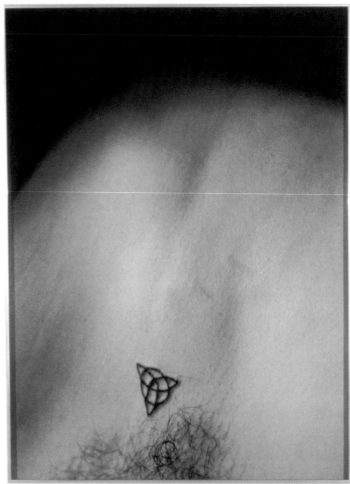

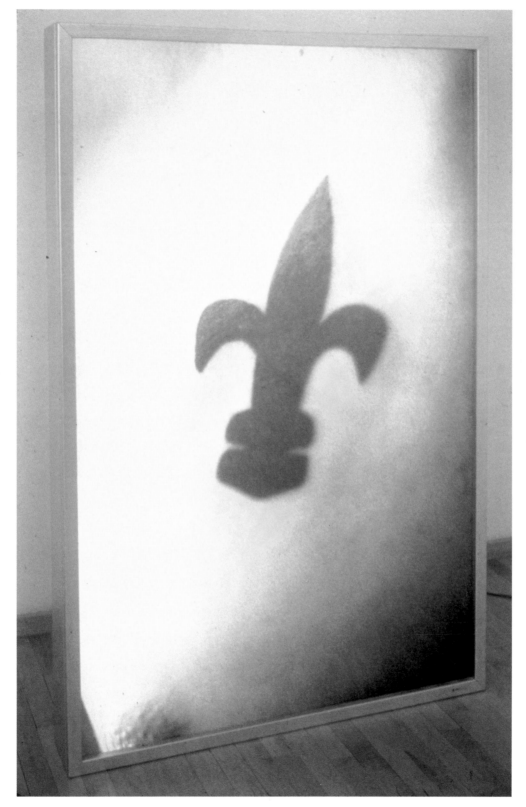

I photographed all the tattoos right after they were finished. The skin around this fleur-de-lis tattoo was especially tender and red. I wanted to highlight that, so instead of exhibiting it as a framed photo, I made it into a light-box installation.

73

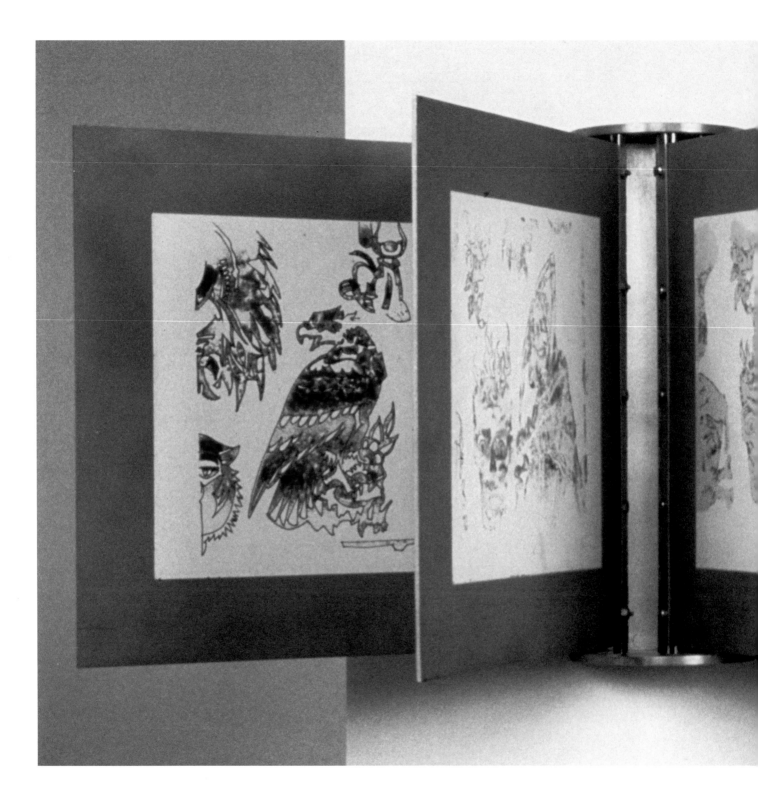

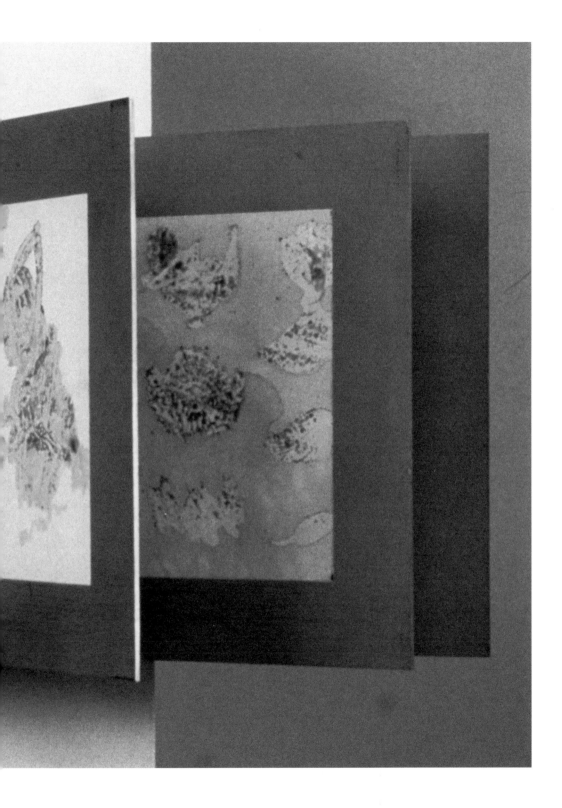

This sculpture of drawings made
from tattoo flash mounted
on aluminum is modeled after the
display racks in tattoo shops.

XII.
FLIGHT SERIES

[2000–ONGOING]

DATE 19 99	AIRCRAFT TYPE	AIRCRAFT IDENT	ROUTE OF FLIGHT FROM	ROUTE OF FLIGHT TO	REMARKS AND ENDORSEMENTS	NR INST. APP.	NR LDG	AIRCRAFT CATEGORY SINGLE-ENGINE LAND		MULTI-ENGINE LAND	
2/5	C172	64B15	COW	COW	Engine start, taxi, Climbs Straight & level & turns, descents		1	0	8		
4/01	C172	N967SP	BFI	BFI	Bcsi flight, Climbs, Turns Descents Stl		1	1	1		
5/2/01	C172	N97PD	BFI	BFI	B Climbs at Vy, Turns Turning descents, preflight		1	1	1		
5/21	C172	N97PD	BFI	BFI	Climbs, Turns descents review, radio ops		1	1	2		
5/23	C172	N97PD	BFI	BFI	Climbing Turns descents dutch rolls radio, taxi		1	1	3		
5/26	C172	N9537Q	BFI	BFI	Climbs Turns descents taxi, radio ops, slow flight		1	1	1		
5/27	C172	N9537Q	BFI	BFI	Slow flight, goarounds, taxi radio, ops		1	4	2		
5/29	C172	N9537Q	BFI	BFI	Slow flight, stalls. go arounds radio ops.		1	1	2		
6/4	C172	N97PD	BFI	BFI	Slow flight, Taxi, radio ops Climbs, Go arounds		1	1	5		
6/12	C172	N95129	BFI	BFI	slow flight, stalls, Landings go arounds, radio ops		1	1	8		
6/13	C172	N95129	BFI	BFI	Stalls slow Flight Basic attitude expandref.		1	1	6		
6/15	C172	N9537Q	BFI	BFI	Turns about a point Rect patterns Landing		1	1	3		
6/18	C172	N967SP	BFI	BFI	App/Dep Stalls Hoodwk, Unusual Attree		1	1	8		

I certify that the entries in this log are true,

PILOT'S SIGNATURE

TOTALS THIS PAGE	17	0
AMT. FORWARDED		
TOTALS TO DATE	17	0

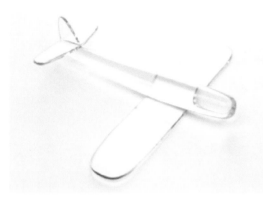

Ever since seeing "To Fly" at the National Air and Space Museum in Washington, DC, in second grade, I've been interested in flight. I went to flight school in Seattle, training to get my pilot's license. I started on a Cessna and then I switched to a Diamond Evolution. I was working on my landings when 9/11 happened and all flight-school students were grounded.

AND CLASS		CONDITIONS OF FLIGHT			FLIGHT SIMULATOR	TYPE OF PILOTING TIME						TOTAL DURATION OF FLIGHT	
		NIGHT	ACTUAL INSTRUMENT	SIMULATED INSTRUMENT (HOOD)		CROSS COUNTRY	AS FLIGHT INSTRUCTOR	DUAL RECEIVED		PILOT IN COMMAND (INCL. SOLO)			
2572685 CFI								0	8			0	8
264655 CFI 03/03		Peter C						1	1			1	1
264655 CFI 03/03		Peter C						1	1			1	1
64655 CFI 03/03		Peter C						1	2			1	2
64655 CFI 05/03		Peter C						1	3			1	3
64655 CFI 05/03		Peter C						1	1			1	1
64655 CFI 03/03		Peter C						1	2			1	2
64655 CFI 03/03		Peter C						1	2			1	2
64655 CFI 03/03		Peter C						1	5			1	5
64655 CFI 05/03		Peter C						1	8			1	8
64655 CFI 05/03		Peter C						1	6			1	6
64655 CFI 05/03		Peter C						1	3			1	3
64655 CFI 05/03		Peter C		4				1	8			1	8
				4				17	0			17	0
				4				17	0			17	0

Above, my logbook from the Galvin Flight School in Seattle.
At top, a model plane. I worked with a glassblower to design an edition of airplane sculptures.

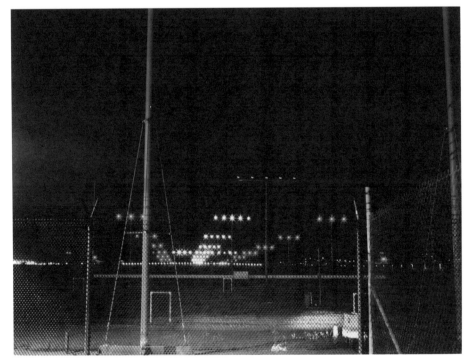

78

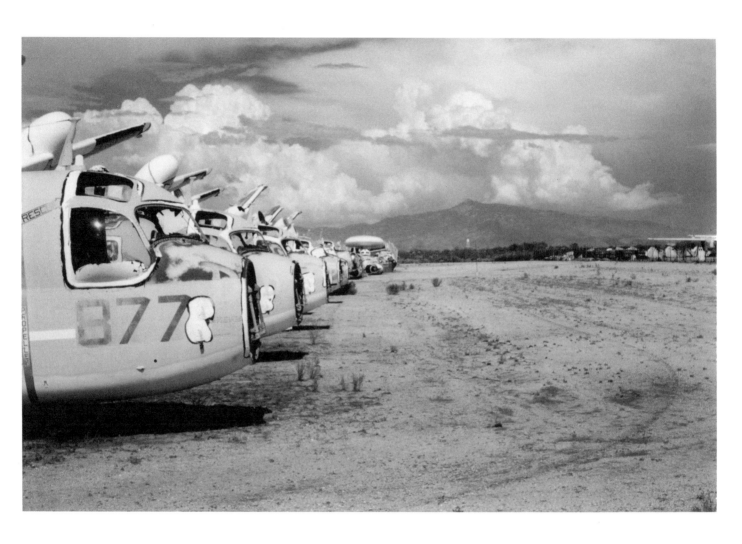

Above, Dead Airplane Field in Tucson, Arizona.
Left, LAX runway at night.

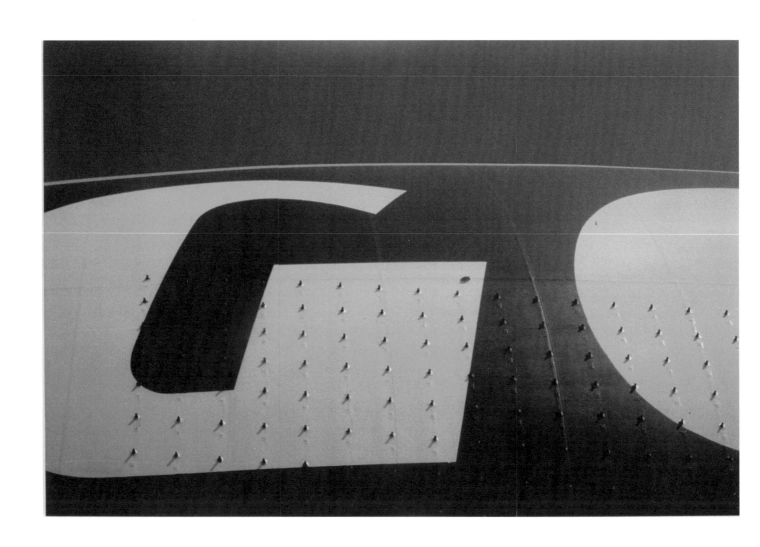

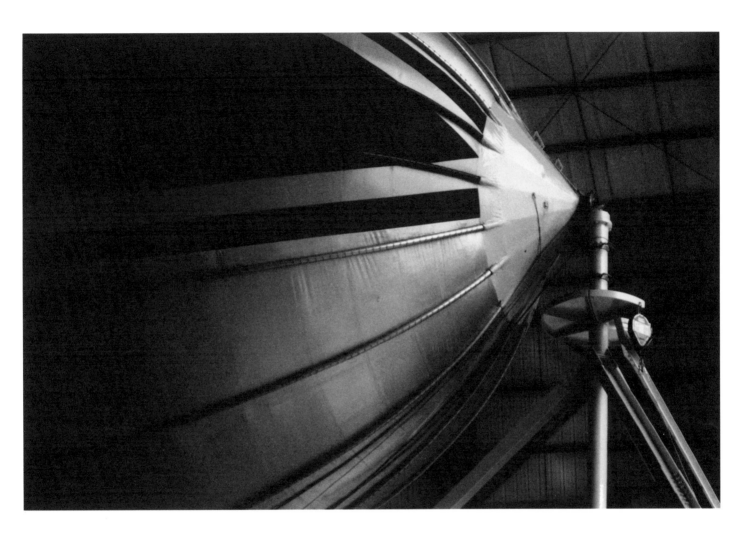

I flew the Goodyear blimp in New York and in Florida. It's very slow moving, so it's more like you're just sitting at the controls.

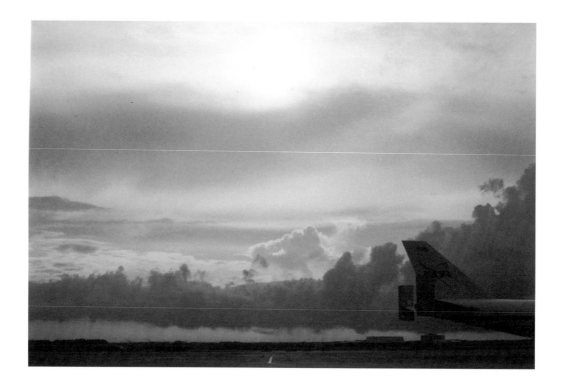

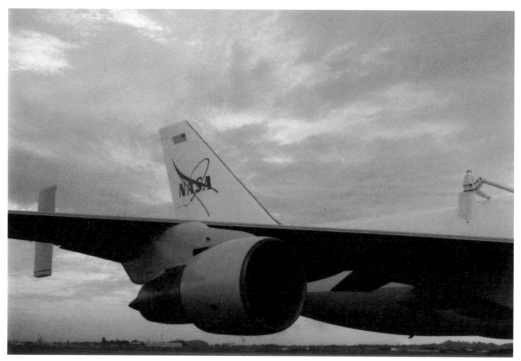

A NASA runway in Houston.

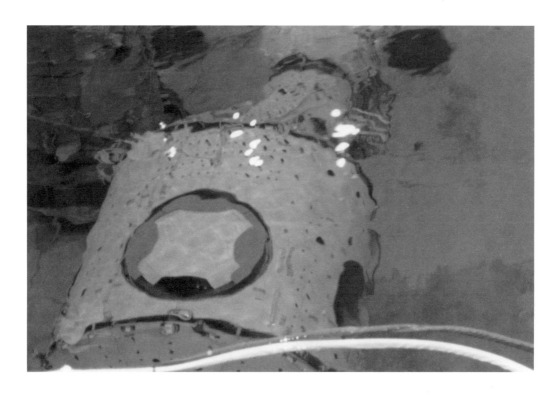

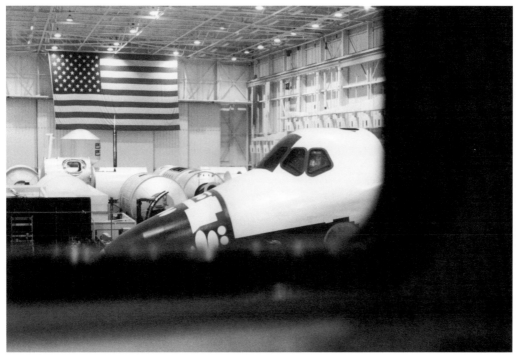

Above, the Hubble telescope in NASA's neutral buoyancy tank. Below, inside a hangar at NASA.
I landed the space-shuttle simulator twice. The first time I crashed and "killed everybody."
The second time I managed to keep it on the runway.

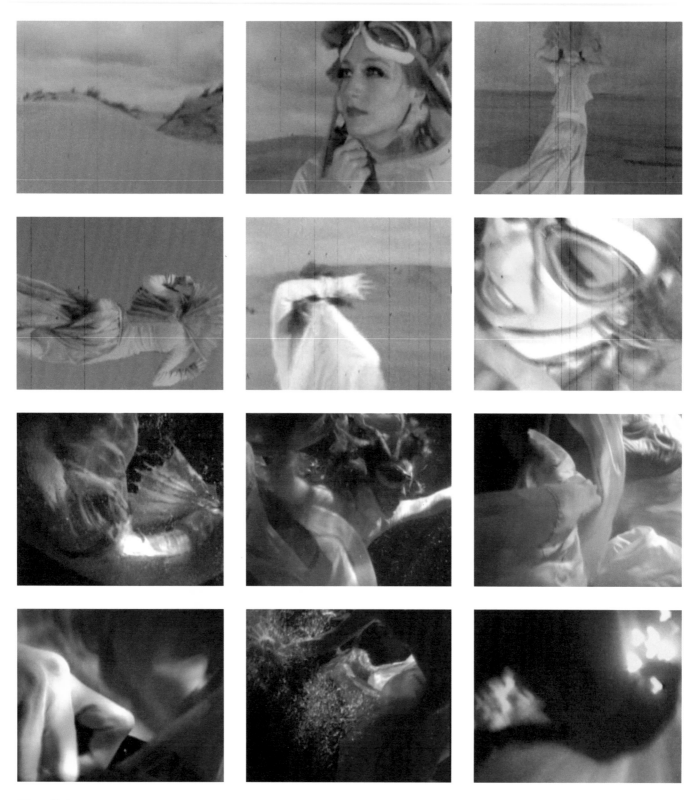

Film stills from *Icarus*.

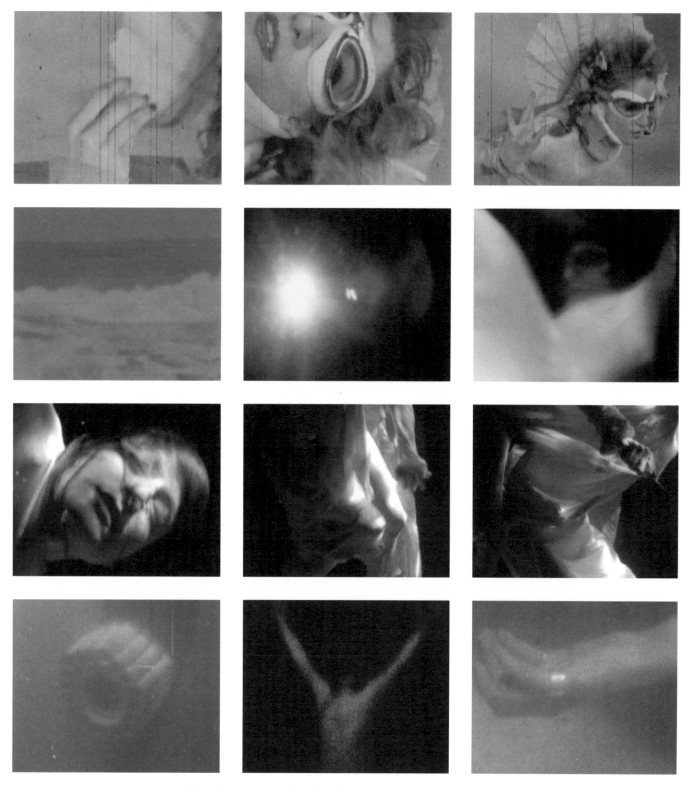

When I was learning to fly, I thought a lot about about Amelia Earhart and Icarus—two mythic figures who met their ends in flight. We shot the film in Washington state, North Carolina, and a swimming pool in Baltimore.

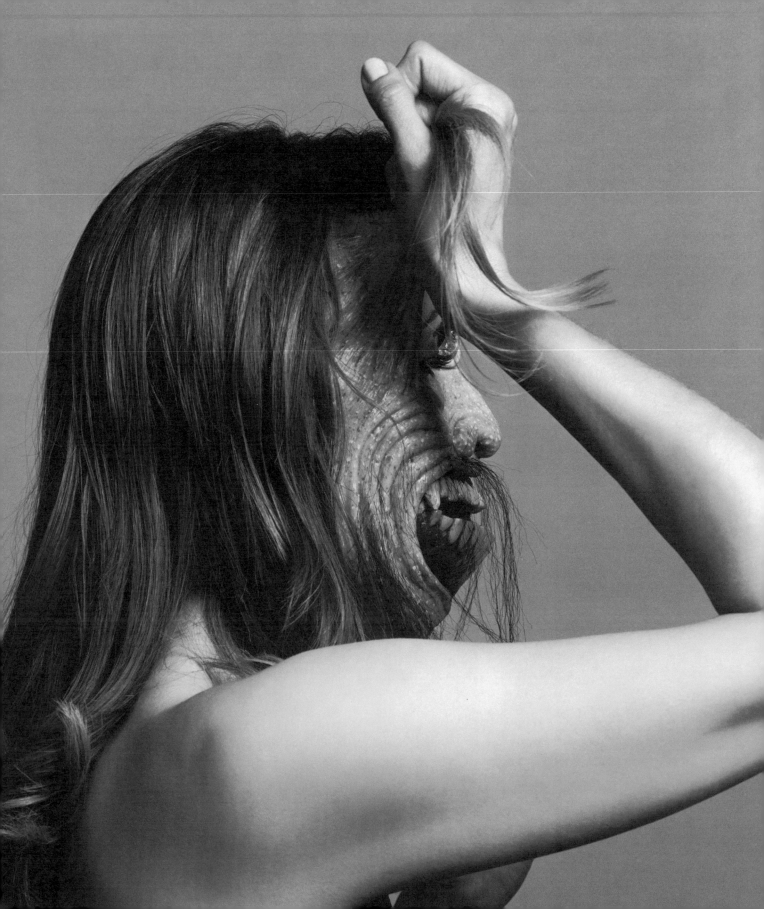

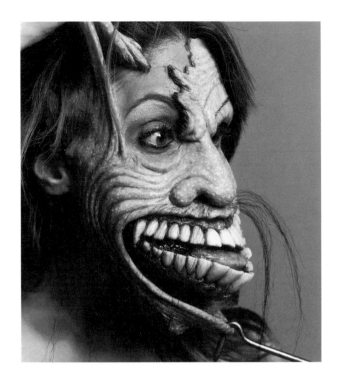

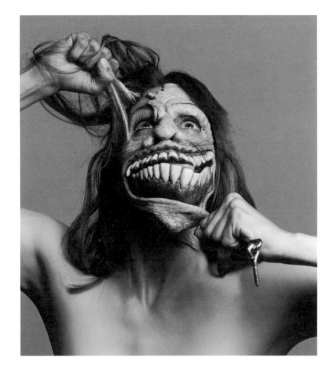

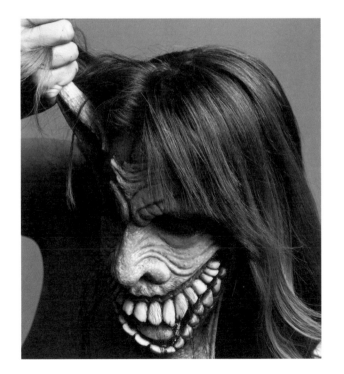

XIII.
ADRIAN
MESSENGER

[2005]

I'm a big fan of the film *The List of Adrian Messenger*, which came out in 1963. It featured a lot of big stars, but they were all hidden under major movie makeup. It was the first time that a film had really celebrated what you could do with prosthetics. Collaborating with Gabe Bartalos, a special-makeup-effects artist, I decided to do something similar.

87

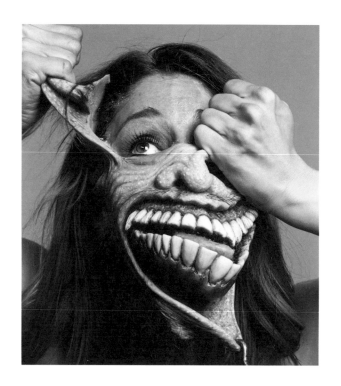

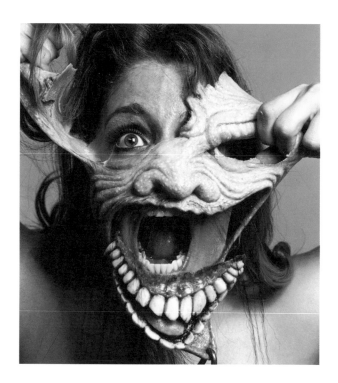

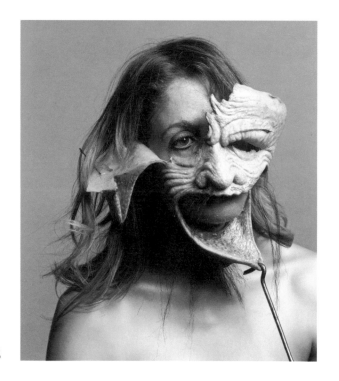

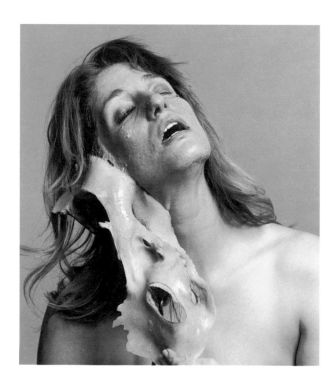

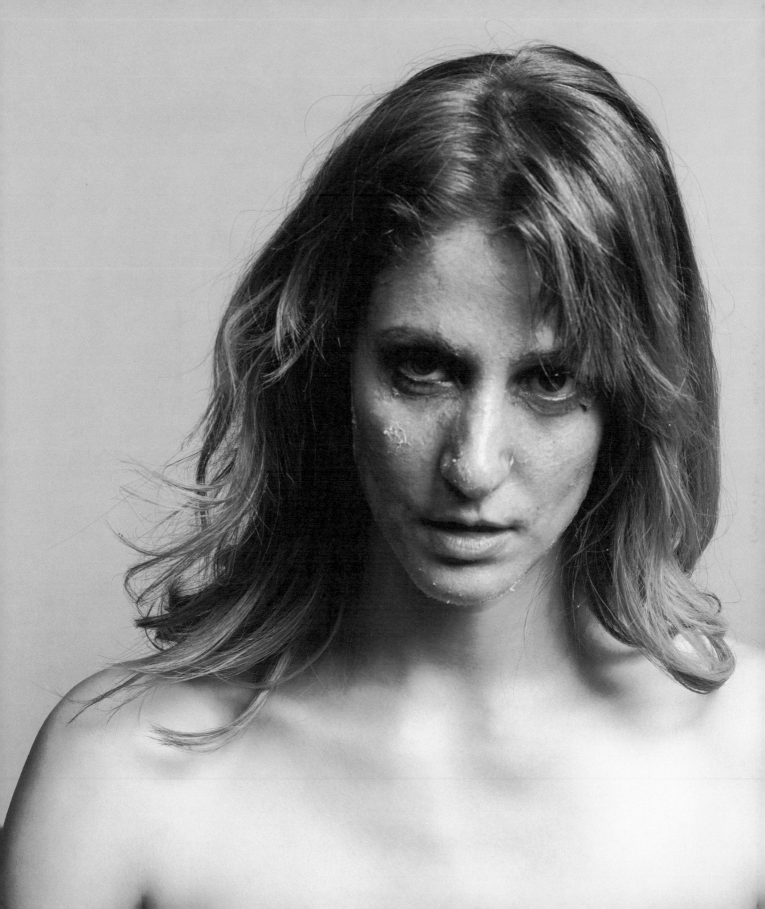

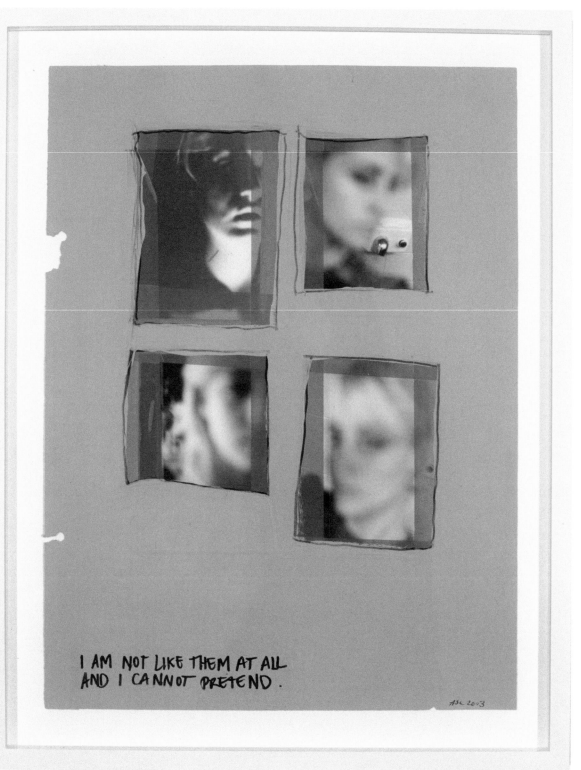

I AM NOT LIKE THEM AT ALL
AND I CANNOT PRETEND.

ASC 2003

XIX.
I AM NOT LIKE THEM AT ALL AND I CANNOT PRETEND

[2002–ONGOING]

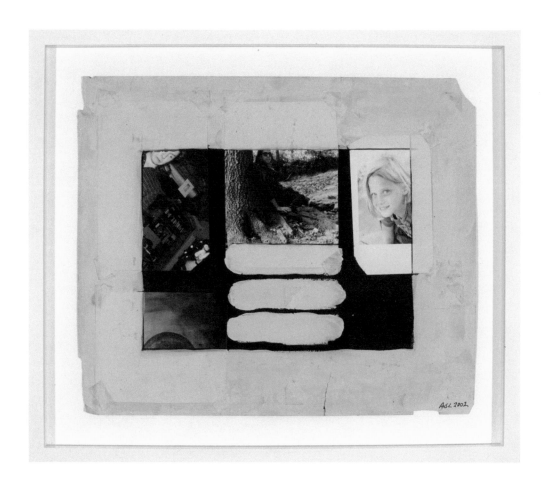

I took my scrapbooks, photo albums, journals, and sketchbooks starting from when I was 12 and "edited" them with paint. I started by cutting out the pages that seemed interesting and then painting over parts of them. They became paintings that simultaneously conceal and reveal.

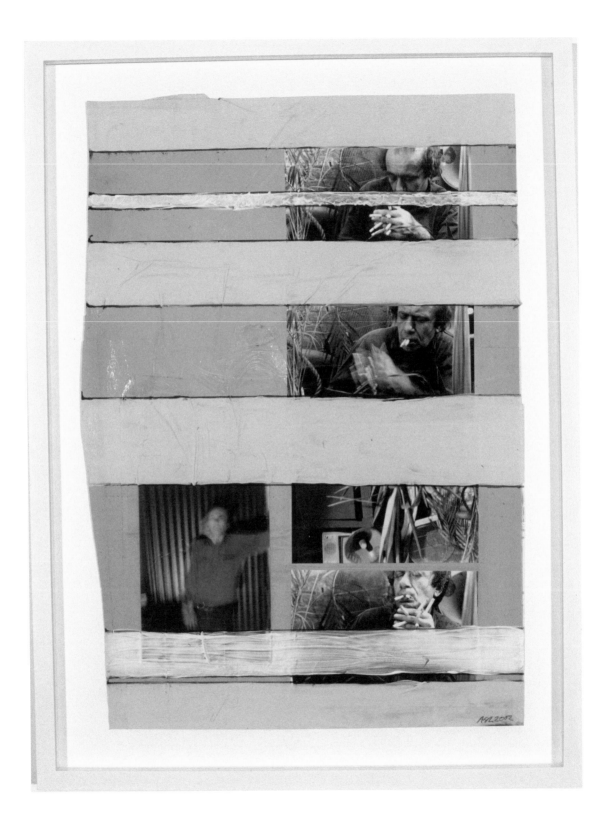

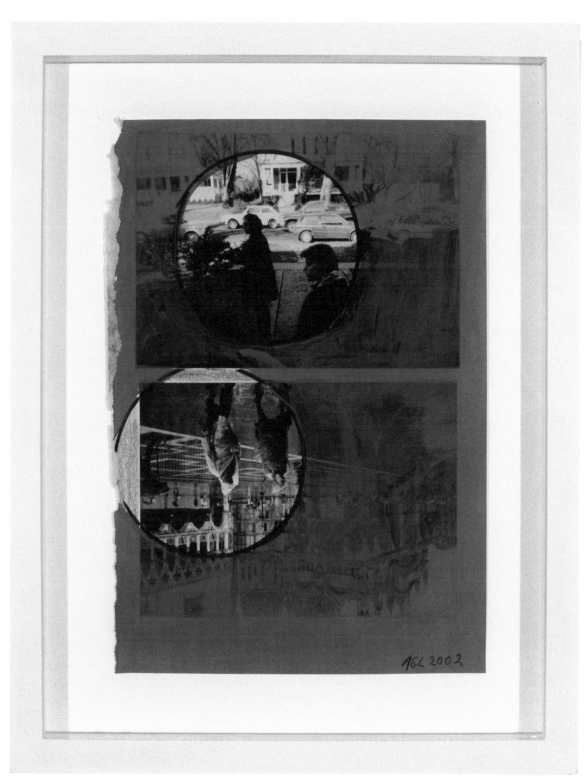

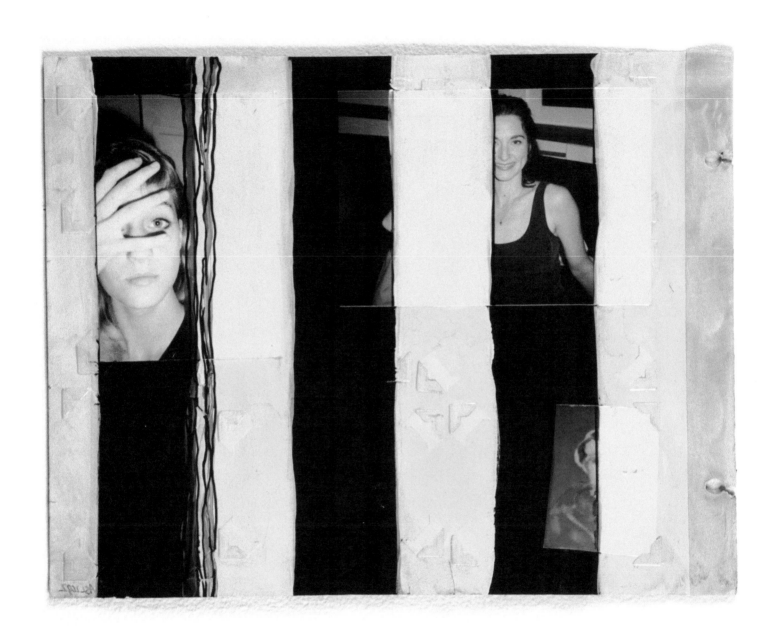

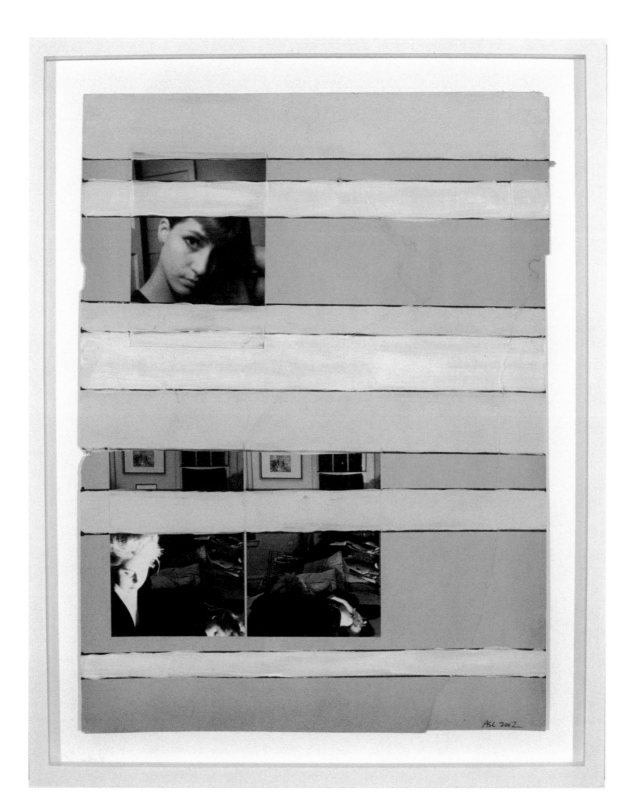

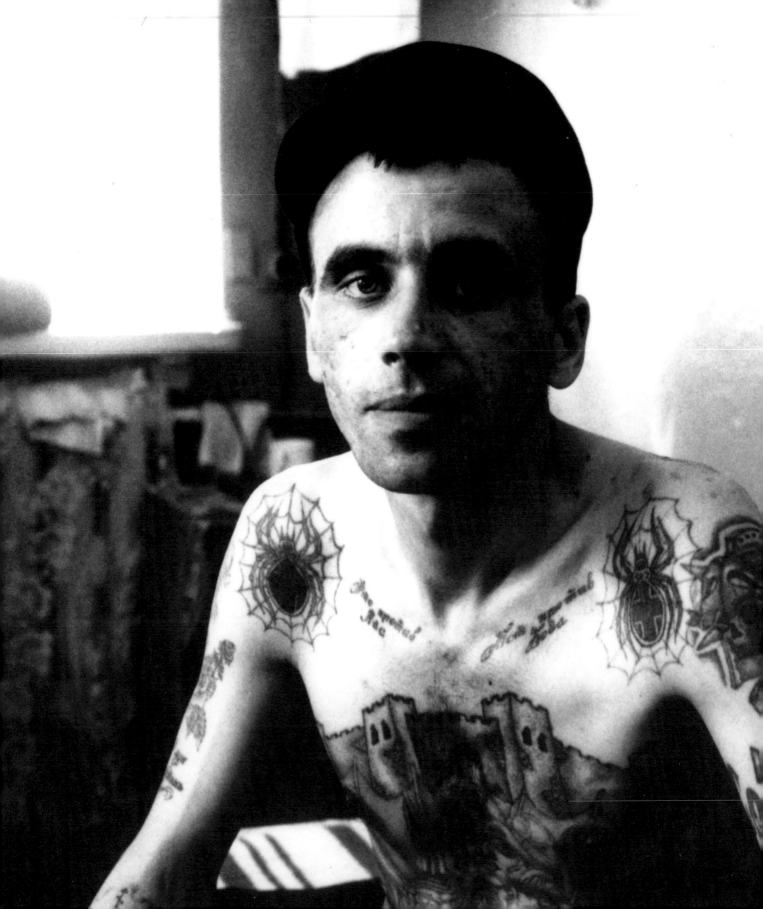

XX.

THE MARK OF CAIN

[1999–2000]

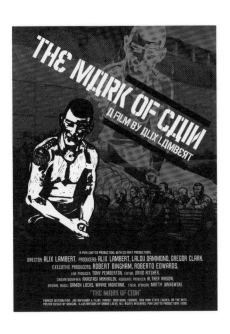

A friend gave me an article on the tattooing practices in Russian prisons. I thought the tattoos were beautiful—the prisoners use makeshift equipment to make extraordinary art. It's a nonverbal language that's dying out. Each tattooed image has a specific meaning that other prisoners can understand. To find out more, I went to the first-ever tattoo convention in Moscow with cinematographer Peter Strietmann, where we met two criminologists who had been documenting these tattoos for years. When I raised enough money I went back to Russia and spent three and a half weeks filming in eight different prisons, both men's and women's.

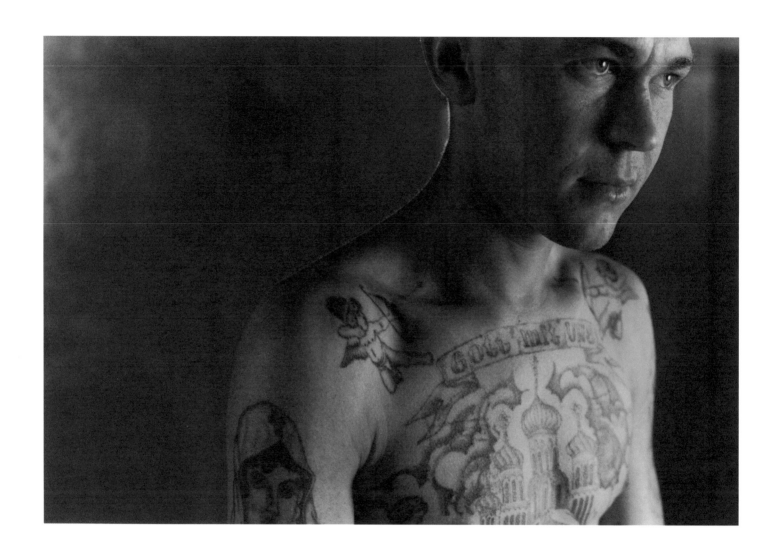

Above, a popular tattoo is "Gott mit uns," or "God is with us," in German. Top right, older prisoners like Viktor Tyryakin spent many years in prison under the Communists. His tattoos of Stalin, Lenin, and Engels were meant to protect him—if he was ever put in front of a firing squad, guards would not shoot at them. Below, as a young prisoner Sergei Shmon wore a tattoo of a heart pierced by a knife without knowing that it signified he was a hired killer. He has since removed it by pouring manganese on it.

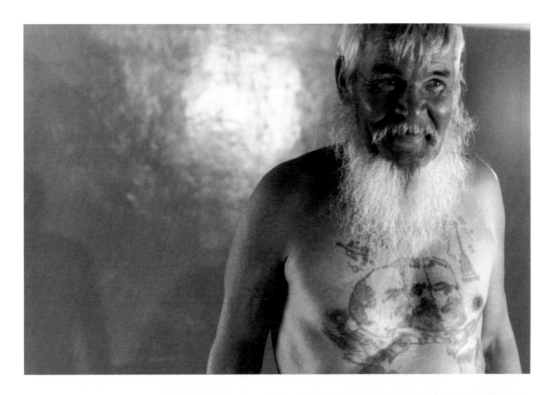

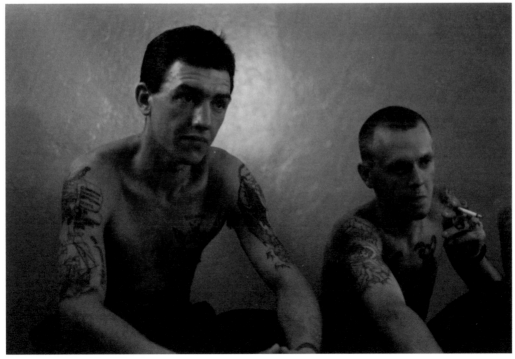

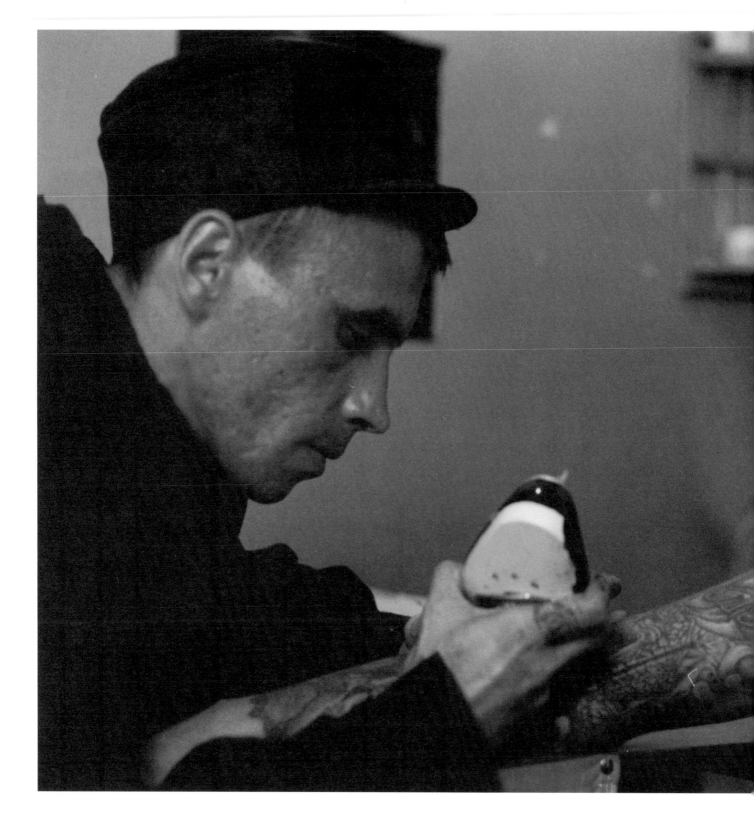

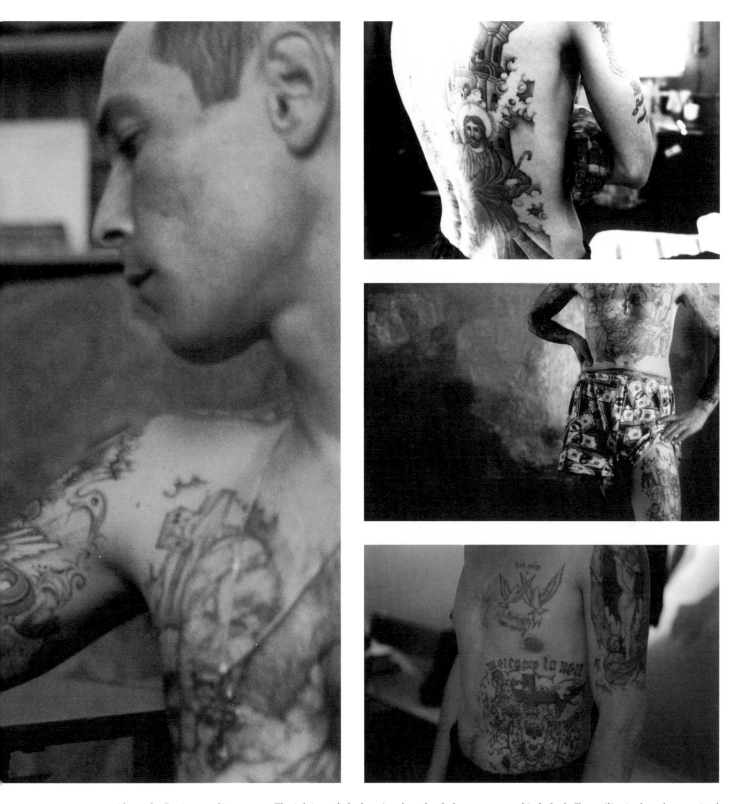

Alexander Borisov applies a tattoo. The ink is made by burning the sole of a boot to create a kind of ash. To sterilize it, the ash gets mixed with the urine of the person being tattooed. The needle consists of a sharpened guitar string threaded through a windup razor.

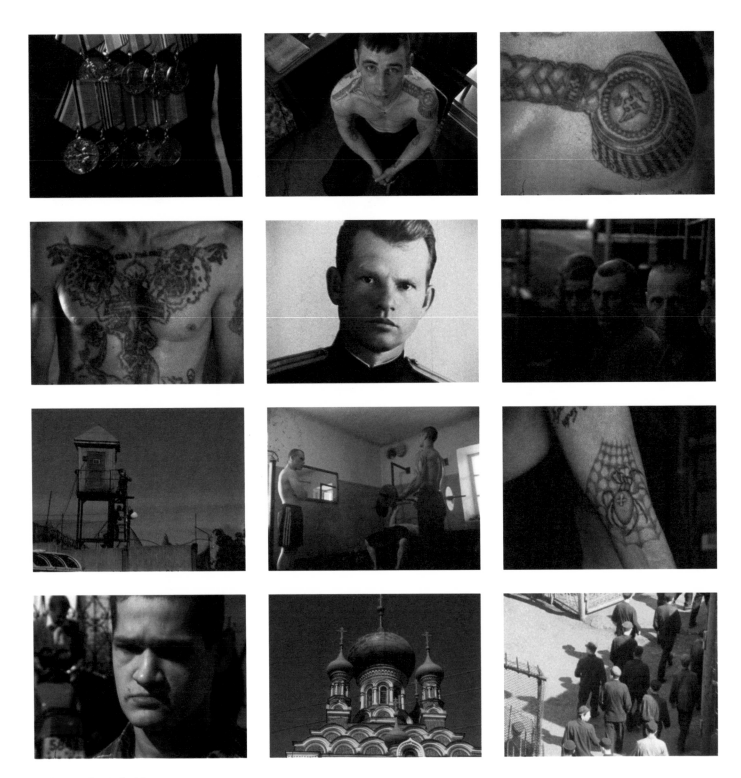

Stills from *The Mark of Cain*.

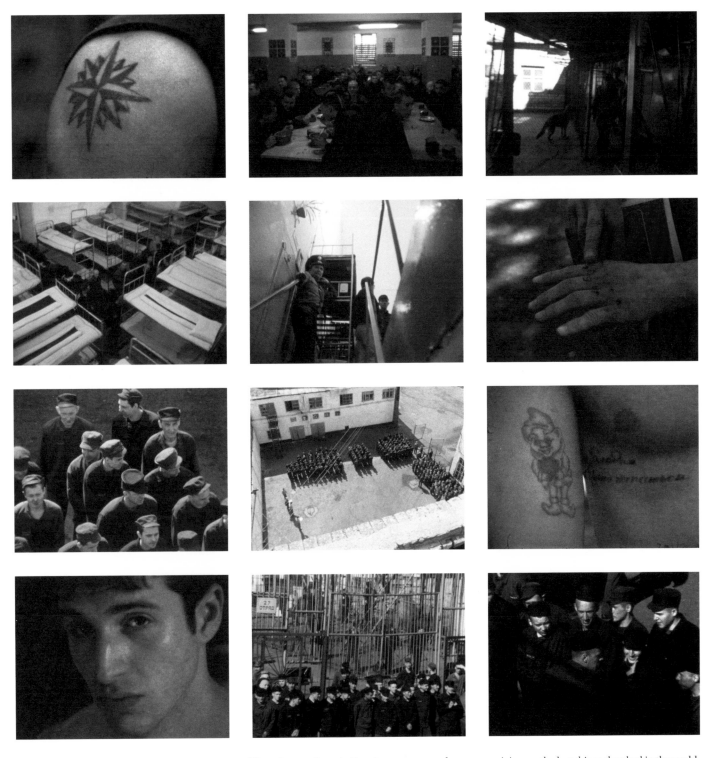

The prisoners I met in Russia were open and generous, giving me the last things they had in the world. People had told me they wouldn't talk to me and that wasn't the case at all. Many of them were articulate, intelligent, and well-read. Simultaneously, the violence and brutality of their lives was palpable.

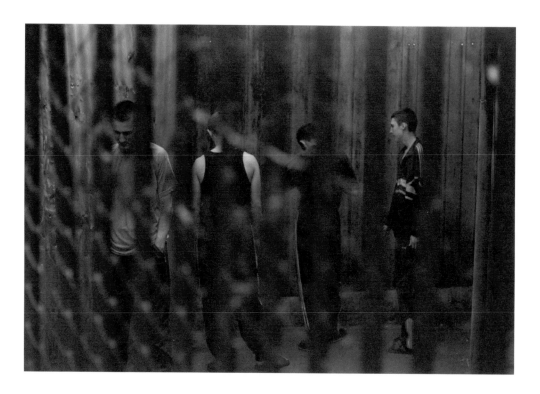

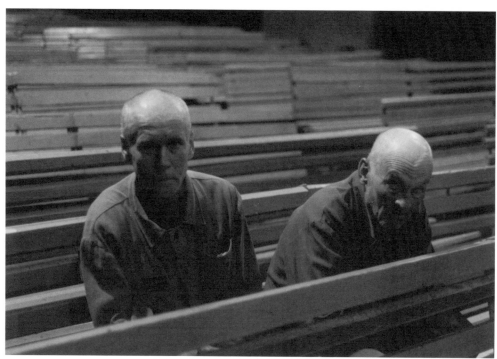

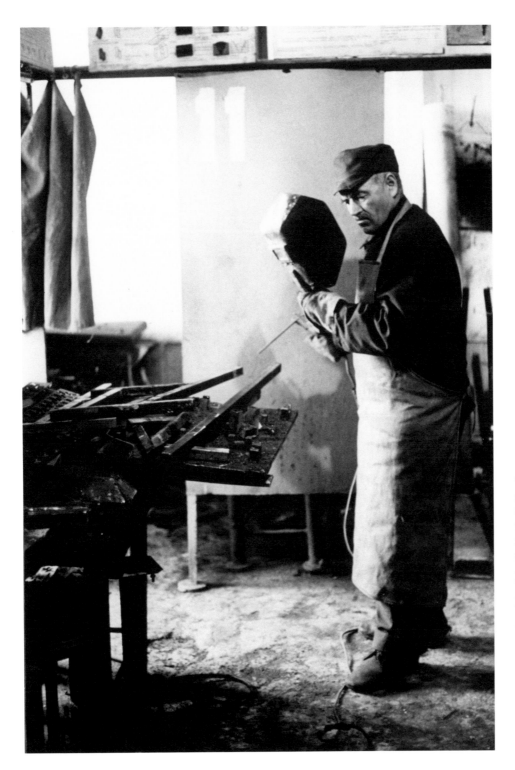

This page, prison labor raises a portion of the funds used for operating the prisons. Metalwork, for the men, and garment sewing, for the women, are common jobs. Top left, prisoners pace outside, where, if they are in solitary, they get to spend only one hour a day. Below, two prisoners sit in a common area.

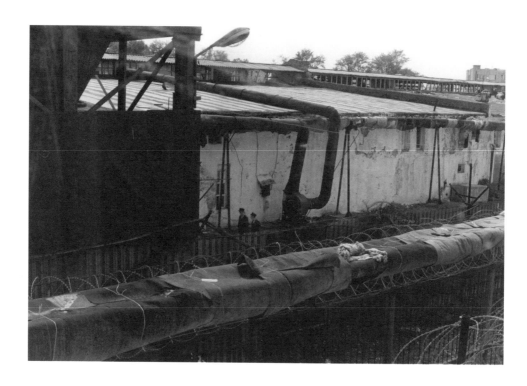

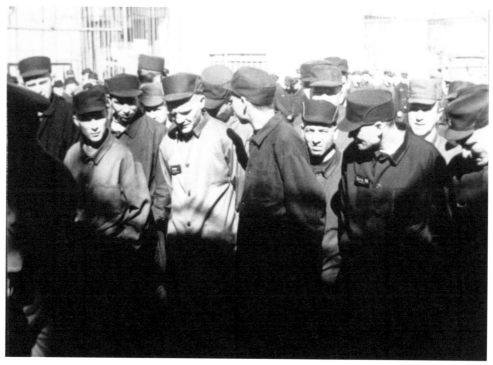

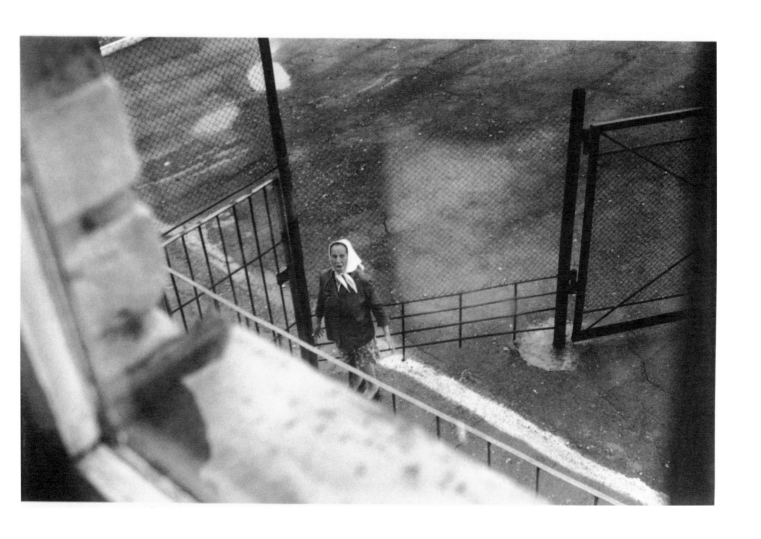

Above, at a women's prison in Perm, white kerchiefs are regulation headgear. We found many of the same conditions in the women's prison as we did in the men's. Top left, the grounds of a prison in Perm. Below, prisoners congregate in the yard, where, several times a day, they are called by name in order to ensure that they are accounted for.

XXI.
COP SERIES

[2003]

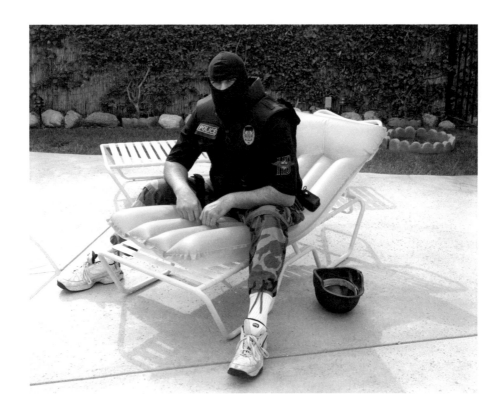

After I finished *The Mark of Cain*, *Nightline* dedicated an episode to it. Then I got a call from the FBI inviting me to screen the film at a law-enforcement convention about Russian organized crime. (They gave me a framed plaque in thanks for my participation.) I met many detectives and undercover cops, whom I became interested in photographing. One undercover cop agreed to let me photograph him and his family at home. The world of law enforcement seemed like an obvious flip side to the world of criminals.

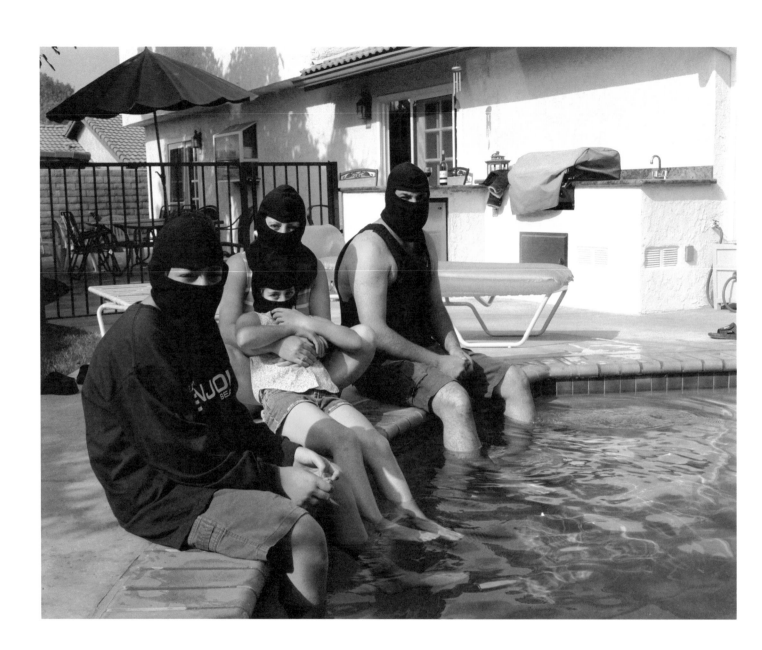

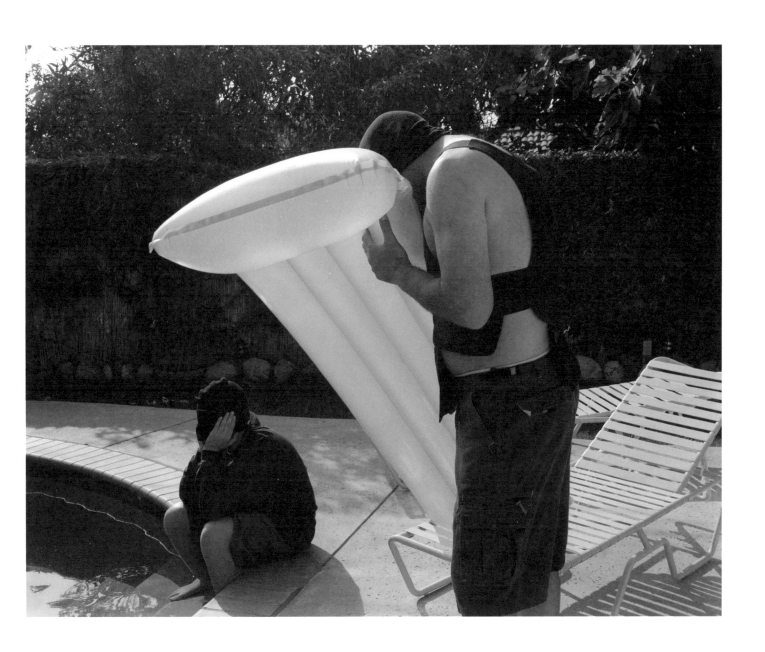

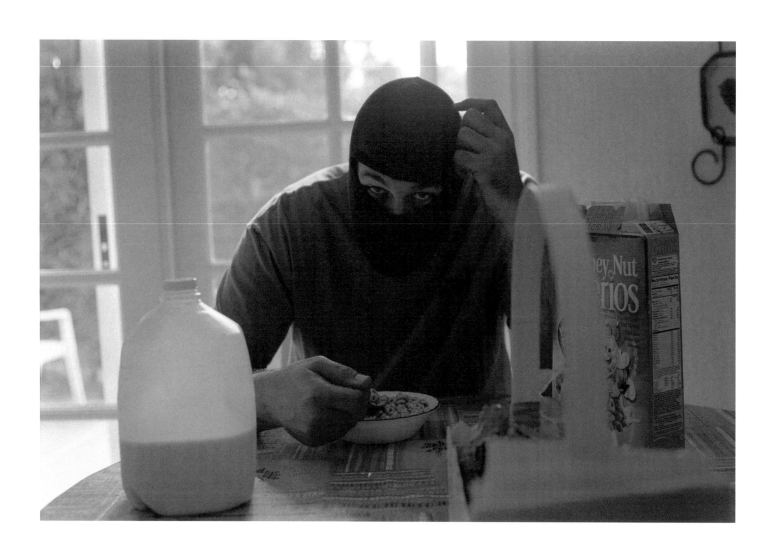

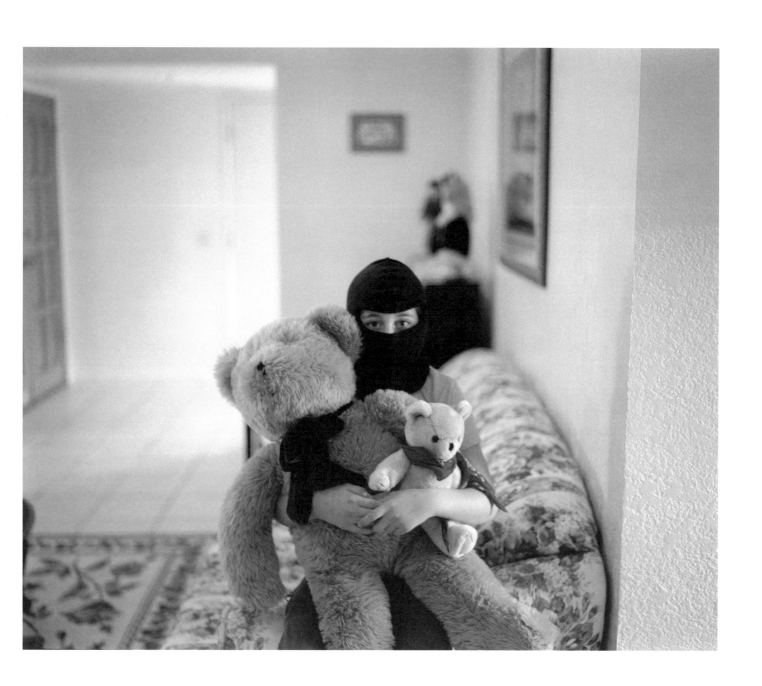

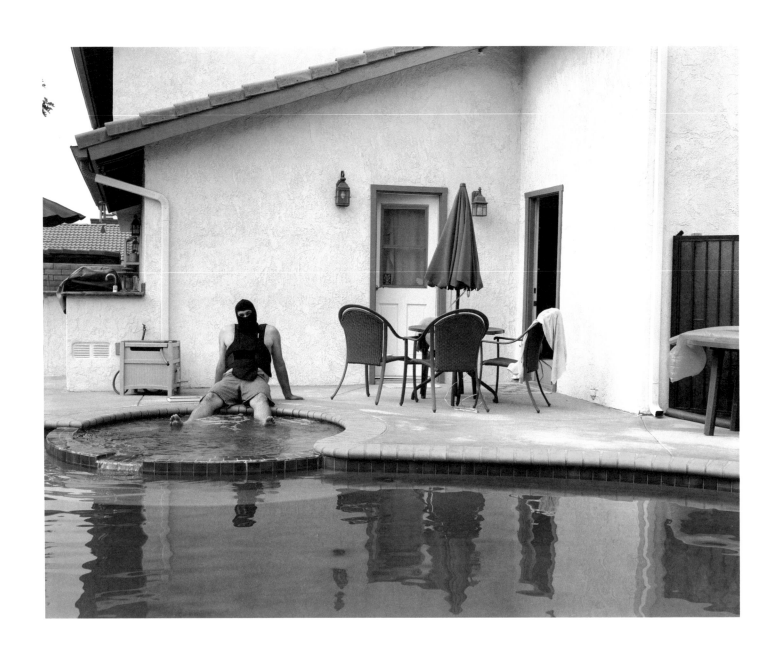

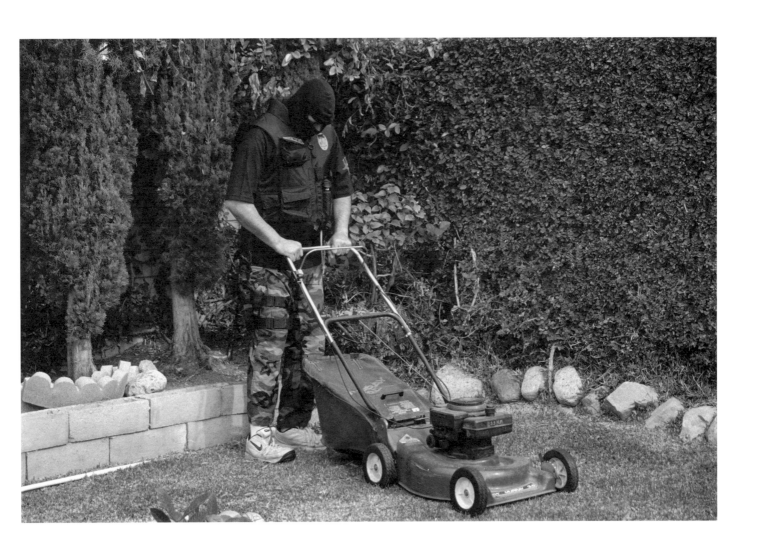

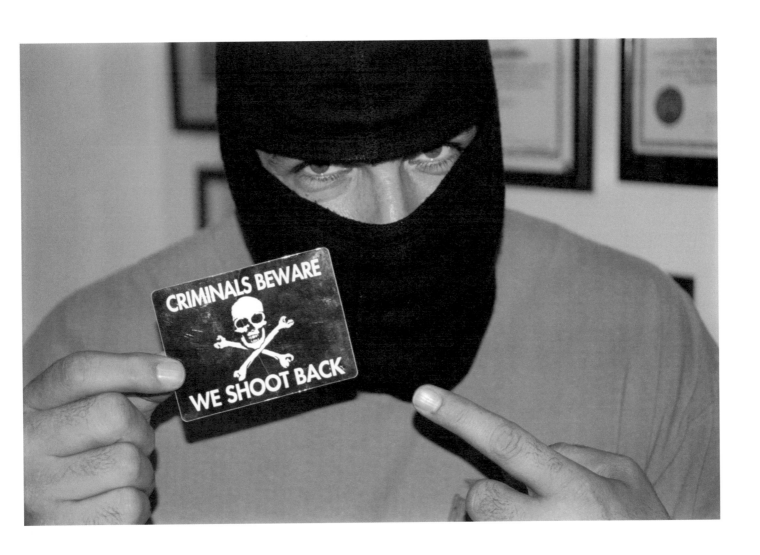

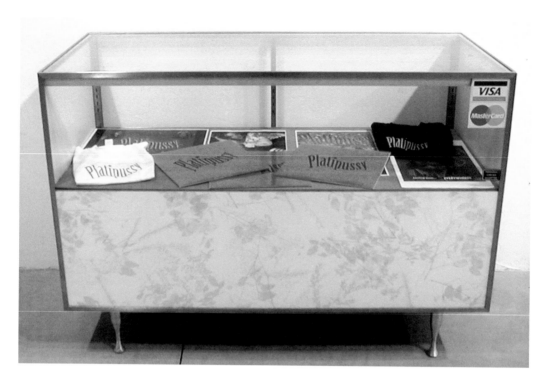

INDEX OF ARTWORKS IN THE BOOK

118

119

ALIX LAMBERT EXHIBITION HISTORY

2002 * *Body Lines*, Museum of David, Jerusalem
Tutto Bene, Hall del'ecal, Lausanne

2001 *Only Skin Deep: Changing Visions of the
American Self*, International Center for
Photography, New York
Bogus, Castle Gallery, New Rochelle,
New York
Chelsea Rising, Contemporary Art Center,
New Orleans

2000 *Never Never Land*, Florida Atlantic University,
Boca Raton, Florida
Side Lines, Makor, New York
Kingsway Trilogy, video wall, Sara Meltzer
Gallery, New York
Game On! Sara Meltzer Gallery, New York
New Photography, Baumgartner Gallery,
New York
Human Being and Gender, Kwangju
Biennale 2000, Korea
Gender and Identity, Parrish Museum
of Art, Montauk, Long Island

1999 Curt Marcus Gallery, New York
Antiworld, Gallery Untitled, Dallas, Texas
Photography Salon, Elizabeth Cherry Fine
Arts, Tucson, Arizona
Hazmat, Museum of Contemporary Art,
Tucson, Arizona

1998 *Vanessa Beecroft / Alix Lambert / Helmut
Newton*, Espace Lausannois d'Art
Contemporain, Lausanne
Super Freak, Greene-Naftali Gallery,
New York
Forde's Needles, Forde Espace d'Art
Contemporain, Geneva

1997 *The Young and Restless*, Museum of Modern
Art, New York. Traveled to the Filmmakers
Co-op, London; Contemporary Art Museum,
Honolulu; Henry Art Gallery, Seattle;
Kunstakademiet, Trondheim; Kunstbunker
Tumulka, Munich; Cornell Cinema, Ithaca,
New York; WRO Festival, Warsaw.
Des Histoires en Formes, Le Magasin and
Centre National d'Art Contemporain,
Grenoble.

1996 *Up Close and Personal*, Philadelphia Museum
of Art, Philadelphia
* *Ferbedienung: Does television inform the
way art is made?* Grazer Kunstverein, Graz,
Austria

Trois collections d'artistes, Musée des
Beaux-Arts, La Chaux-de-Fonds
* *Push-Ups*, The Factory, Athens Fine Arts
School, Athens

1995 *All Dressed Up*, Apex Art, New York
* *féminin-masculin / Le Sexe de l'Art*, Centre
Georges Pompidou, Musée National d'Art
Moderne, Paris
Mini Mundus, White Columns, New York
Drawings & Drawings, Galerie Kees Van
Gelder, Amsterdam
Prospect 1986–94, Galerie Art & Public,
Geneva

1994 *Arte in Video*, Inter Nos, Milan
* *Oh boy, it's a girl! / Feminismen in der
Kunst*, Kunstverein München, Munich.
Traveled to the Kunstraum Wien, Vienna.
Who Chooses Who, New Museum of
Contemporary Art, New York
* *Audience 0.01*, Trevi Flash Art Museum,
Trevi, Italy. Traveled to Otis Gallery,
Los Angeles, and Daniel Newburg Gallery,
New York.
* *L'Hiver de l'amour / Winter of Love*, Musée
d'Art Moderne de la Ville de Paris ARC,
Paris. Traveled to P.S.1., New York.

1993 *Self Winding*, Nanba City Hall, Osaka.
Traveled to Sphere Max, Tokyo.
* *The Return of the Cadavre Exquis*, Drawing
Center, New York. Traveled to the Corcoran
Gallery of Art, Washington, D.C.; Santa
Monica Museum of Art, Santa Monica; Forum
for Contemporary Art, Saint Louis, Missouri;
and the American Center, Paris.
De Passage . . . / Furkart 93, Furkapasshöhe,
Hotel Furkablick, Switzerland
* *Aperto '93*, Venice Biennale

1992 *A Whiter Shade of Pale*, Galerie Sophia
Ungers, Cologne
BACA Downtown, Brooklyn, New York
Andrea Rosen Gallery, New York

1991 *H.O.M.E. for June*, H.O.M.E. for
Contemporary Art, New York
Friendly, Dooley Le Cappellaine Gallery,
New York

* Catalog Publication

121

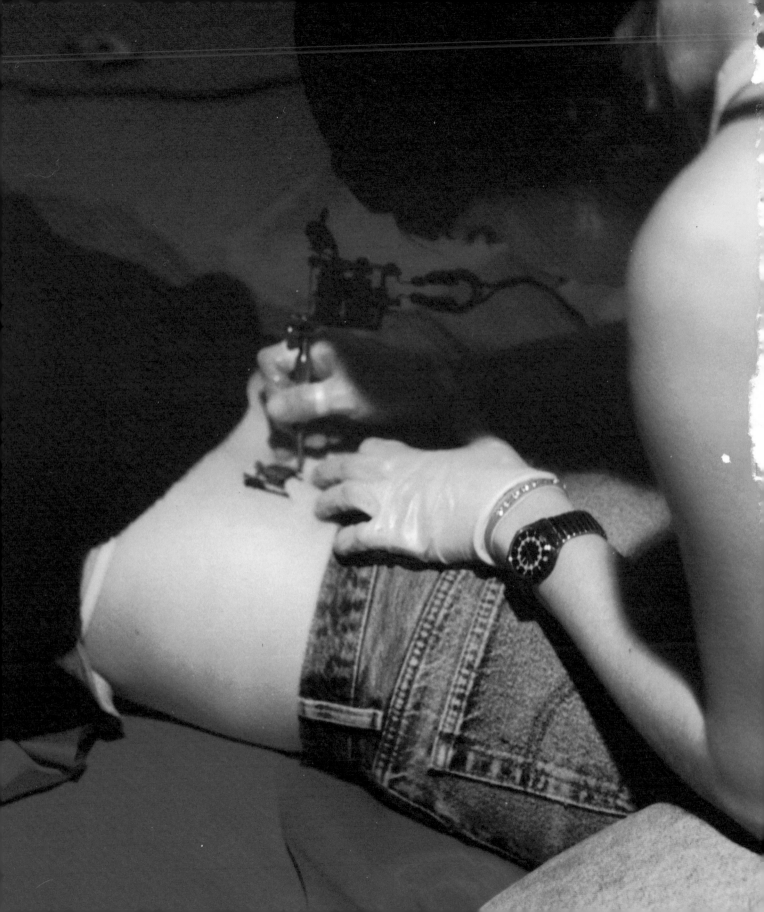